THE
ARTS
DIVIDEND

THE ARTS DIVIDEND

WHY INVESTMENT IN CULTURE PAYS

DARREN HENLEY

First published 2016 by
Elliott and Thompson Limited
27 John Street
London WC1N 2BX
www.eandtbooks.com

ISBN: 978-1-78396-277-8

Poem on page 32: From *Search Party* by George the Poet, published by
Virgin Books. Reproduced by permission of The Random House Group Ltd.

All author royalties earned from the sale of this book will be donated to
a scholarship fund for postgraduate students at the University for the
Creative Arts.

9 8 7 6 5 4 3 2 1

A catalogue record for this book is available from the British Library.

Typesetting: Marie Doherty
Printed in England by TJ International Ltd

contents

about this book

This book contains my personal reflections on England's arts and cultural landscape in 2016, one year on from my appointment as the chief executive of Arts Council England.

It is not an official Arts Council publication; these are my personal opinions, but they have been shaped by my experiences and by the people I have met in that first year. And while I am writing about the effect of art and culture generally, I have seen the impact of the investment that Arts Council England makes, and it is inevitable that what I cover should reflect that insight.

I have chosen to write down my experiences and the perspective they have informed now, in case there should ever come a time – simply because it has all become much more familiar – when our national art and culture seems less remarkable to me than it really is.

In England, we are blessed with unique creativity. It's too easy to take it for granted. We should remember all that it does for us, and talk about it.

introduction

This book argues that public funding for art and culture is import-
ant because a sustained, strategic approach to cultural investment
pays big dividends in all of our lives.

I understand that words such as 'investment' and 'dividends' might
be dismissed as economic rather than creative terms. Where's the
art in all this? The point I'll make is that these dividends flow only
when the art excels. The list of criteria that guides the Arts Council
is headed by the concept of great art and culture; while there will
always be a healthy debate about what quality means within the
artistic community, the public tend to know straightaway when
they are being fobbed off with something less than the real deal.
To my mind, if you want truly popular, memorable and resonant
art, it has to be the best.

In my previous role in broadcasting, I worked for more than twenty
years bringing some of the greatest works of art to a popular audi-
ence, so I don't understand the distinction some make between
'great' and 'popular'. There are works of art that are ahead of their
time, but few artists have ever striven not to be read, or to have
their work leave people untouched. The greatest art is the most
human. Given time, it will always find its audience.

This doesn't mean that all art will be equally popular in every public constituency. Taste, custom and history have to be taken into account – elements intrinsic to the richness of our national culture – and these are every bit as influential as the aesthetic traditions of an art form.

Artists must be able to challenge preconceptions, to think differently and freely, and to create great art in new ways. It's only by encouraging the diversity of individual artistic perspectives that you can ensure that you are reflecting the lives, loves and interests of audiences – that everyone is getting the best.

From a funding perspective, what matters is that you support talent and champion ambition, innovation and risk. These are integral to creativity. We don't want to dilute these values.

Great art changes people's lives. I'd like all our museums, our libraries, our artists and our arts venues to be genuinely popular, to be a part of the lives of all their communities, so that everyone in England can enjoy the Arts Dividend and have their lives enhanced, no matter who they are, or where they live.

Over the past year, I've travelled the length and breadth of England, coming to know and understand how our arts ecology works, and I believe we're on the way to realising a vision in which everyone can have access to the best art we can make.

Across England, I've visited exciting new venues: the East Gallery at Norwich University of the Arts; The Word, a brand new centre

for the written word in the heart of South Shields; The Curve, the library and performance space in the centre of Slough; and the newly rebuilt Whitworth Gallery in Manchester.

I've seen work of ambition and innovation: from the exhibitions at Nottingham Contemporary to the technology embraced by artists at Pervasive Media Studio at the Watershed in Bristol; from the work created by young people from Barking and Dagenham at the Studio 3 Arts Centre to the terrific production values of *The Herbal Bed* at the Royal and Derngate in Northampton.

Everywhere you go in England, you'll find brilliant art breaking out in unexpected places: an opera about football in Sunderland Minster; a contemporary dance performance as part of the Dance Umbrella Festival on top of an NCP car park in Farringdon; or the Birmingham Opera Company performing in a disused warehouse on an inner city industrial estate.

And this sits alongside the consistent celebration of all that is best about our national culture, whether it's a concert by the Black Dyke Band at the Sage Gateshead, the opening night of the London Jazz Festival at the Barbican Centre, or the cultural riches on show at the Pitt Rivers Museum in Oxford.

❝ *Great art changes people's lives. Artists must be able to challenge preconceptions, to think differently and freely, and to create great art in new ways.* **❞**

These are just a few events and places chosen from my own personal experiences over the past year – and I was only able to take in a fraction of what is on offer, every day.

Put together, these make up a wonderful interconnected cultural ecology that extends across our villages, towns and cities. And, separately, each of them also shows the value of public investment in arts and culture.

Seventy years of public investment

In 2016 the Arts Council marks the seventieth anniversary of the granting of its first Royal Charter. The Arts Council grew out of the Council for the Encouragement of Music and the Arts (CEMA), which was set up in 1940 with the aim of supporting Britain's culture as part of the war effort. The driving force behind the creation of the Arts Council, and its first chairman, was John Maynard Keynes, the economist.

It is salutary to note that it was an economist, rather than an artist, whom generations of creative minds since the Second World War have to thank for the body that provides public investment in their work. Keynes was a passionate believer in the arts. He collected paintings and regularly attended the opera, ballet and theatre. More than half a century ago, he recognised the value that arts and culture brings to our lives.

In a BBC Radio talk in 1946 to announce the Arts Council's establishment, Keynes underlined the importance of creative freedom for the artist:

'...who walks where the breath of the spirit blows him. He cannot be told his direction; he does not know it himself. But he leads the rest of us into fresh pastures and teaches us to love and enjoy what we often begin by rejecting, enlarging our sensibility and purifying our instincts.'[1]

Keynes was the architect of the Arts Council's Royal Charter, although he died shortly before it was ratified. The Arts Council was funded with a grant from the Treasury, operating at arm's length from the government. This principle is still upheld today. In addition to government funding (known as Grant in Aid), since 1994, the Arts Council has also distributed National Lottery Good Causes funding to arts and culture activities across England.

In 2013, almost seven decades on from Keynes's radio talk, the current chair of Arts Council England (and Keynes's successor), Sir Peter Bazalgette, neatly encapsulated the role that culture plays in twenty-first-century England, in his first speech in the job:

'The arts create shared experiences that move us to laughter or tears; that increase our understanding of other people's lives: that educate and entertain us. In short, it is the power of enlightenment.'[2]

the power of the arts.

1 Keynes, John Maynard, 'The newly established Arts Council of Great Britain (formerly CEMA). Its policy and its hopes: a talk by the Lord Keynes', BBC Home Service (8 July 1945)

2 https://www.thersa.org/discover/videos/event-videos/2013/03/sir-peter-bazalgette -inaugural-lecture/#

Things have changed since the days of Keynes. Back in the 1940s, there could sometimes appear to be a lofty separation between artists and the rest of the population, and politicians and funding organisations took a rather patrician view of audiences, who were offered what the establishment thought was good for them, rather than what they might actually want. Those who were 'in the club' were allowed to enjoy the best of art and culture. The rest were likely to be given a watered-down substitute – or nothing at all.

accessibility

In the past, the best art was largely kept away from the population, as if locked up in a cupboard, too remote or expensive or exclusive to be accessed. In the twenty-first century we have blown the doors off that cupboard. The riches are available for everybody to enjoy and the Arts Council puts the needs of the public at the centre of its thinking. Art, culture and creativity are no longer a luxury, remote from everyday life; rather they are an essential part of it.

From 'making the case' to 'making a difference'

If you've read this far, you are more than likely interested in this subject already. Perhaps you work in an arts organisation, a museum, a gallery or a library. Maybe you are a teacher or lecturer educating the generation who will create the great art of the future. You might be involved in political decision-making around the arts at a local or national level or have a career as a painter, a photographer or a sculptor, a dancer, a musician or an actor. You might be a film-maker, a curator, a librarian or an archivist; a poet, a playwright or a novelist. Perhaps you use traditional crafts to create your art – or the latest digital technology.

Whatever your connection with the arts, I hope you agree with Keynes and Bazalgette on the importance of public investment in art and culture.

Perhaps this book will help articulate that belief. But I hope too that it will be a useful read for those who are not directly part of this cultural world and who want convincing about the significance of art and culture – and why it's so important that we continue to invest in these areas of our lives.

Those of us who work closely with art and culture see the benefits, day in and day out. It's our responsibility to make the case for the value of the arts – and for public investment – to the widest possible audience. And we need to get that argument across in ways that make sense.

We can do this most powerfully by showing how public investment in artists, arts organisations, museums, galleries and libraries makes a huge difference, not only to the major cities that are most often talked about, but in every part of the country – in the communal lives of our villages, towns and cities everywhere.

Thinking how we can encourage culture and creativity in less obvious places is a preoccupation of mine, and I am always excited when I visit towns that might not be regarded as conventional tourist hotspots – and discover great cultural riches.

So I was thrilled to walk around a corner in the Huddersfield Art Gallery to see a Henry Moore sculpture, slap bang next to

paintings by L. S. Lowry and Francis Bacon. And when I visited the Royal Albert Memorial Museum in Exeter and the Harris Museum in Preston, I was delighted by the breadth of the artistic riches on show and the obvious pride that people who live there have in their museums and collections.

One of the most striking elements of the English cultural landscape is the abundance of amazing festivals. In Huddersfield, I caught the first concert of its contemporary music festival. I travelled further north for the dramatic opening night of Stockton International Riverside Festival, east for the launch of the Norfolk and Norwich Festival, west for the Cheltenham Jazz Festival and south for the beginning of the Brighton Festival. Each of them provided really excellent art to hungry audiences.

Big cities like Manchester, Newcastle, Liverpool, Leeds, Birmingham and London are surrounded by large population centres, which might not be so well known but still have great civic pride. It's been exciting to walk the streets of Barking, Barnsley, Blackburn, Bradford, Coventry, Croydon, Darlington, Middlesbrough, Southend, St Helens, Stoke-on-Trent, Walsall and Wolverhampton, and to learn first hand how there is a genuine ambition that art and culture should be a part of local life.

You can find the same inspirational message in the towns that dot our coastline, whether it's Bournemouth or Hastings, Great Yarmouth or Penzance – and in counties with big rural areas such as Northumberland, Lincolnshire, Herefordshire and Dorset.

I've visited all these places, and many more besides. I've seen and heard the evidence for myself. Over the coming pages, alongside anecdotal observations from my travels, I will reference some of the mass of research showing the value of investment in art and culture. But I should stress that this book has no academic pretensions. It remains for the general reader, whether they work in the arts or not. I hope that I can help you share my excitement about the immense value of the arts and culture in our lives.

If you see this value, I hope you'll join us to make the case for public investment. And once that case has been made, those of us who work in the arts have to follow through and prove it in practice, ensuring that our artistic and cultural riches are shared with all parts of society.

Making this happen requires foresight, sensitivity to the needs of communities and an understanding of how talent develops. If we plant and protect the acorns of artistic ambition, these will in time grow into magnificent trees. It takes patience, care and sustained investment. But everywhere I've gone, I've seen that public investment is paying dividends – and it will continue to, more and more, in the years to come.

The political argument

In 1964, Harold Wilson appointed Jennie Lee the UK's first arts minister. She built on the work of Keynes, penning a visionary White Paper in 1965 entitled 'A Policy for the Arts: The First Steps'. This contained an unequivocal recognition of the value of art and culture:

'In any civilised community the arts and associated amenities, serious or comic, light or demanding, must occupy a central place. Their enjoyment should not be regarded as something remote from everyday life.' [3]

Let's travel forward into our century, to the House of Commons in November 2015. The Chancellor of the Exchequer George Osborne is announcing his Spending Review for the parliamentary term running through until 2020. In the course of outlining hundreds of billions of pounds of government spending for the next four years, he talked about the value of public investment in art and culture in words that, in their own way, were as unequivocal as Lee's:

'Britain's not just brilliant at science. It's brilliant at culture too. One of the best investments we can make as a nation is in our extraordinary arts, museums, heritage, media and sport. £1 billion a year in grants adds a quarter of a trillion pounds to our economy – not a bad return.' [4]

Just a few months later, in early 2016, the government published the first White Paper on the arts and culture for more than half a century. At its launch, the Culture Minister Ed Vaizey described its relationship to its predecessor:

[3] Lee, Jennie, 'A Policy for the Arts: The First Steps', Her Majesty's Stationery Office (February, 1965)

[4] https://www.gov.uk/government/speeches/chancellor-george-osbornes-spending-review-and-autumn-statement-2015-speech

'Many of the themes it identified in the middle of the 1960s are as relevant today, in the middle of the second decade of the 21st century. The biggest challenge Jennie Lee identified in her White Paper was ensuring that the arts should not be the preserve of a privileged few. Despite enormous changes to arts and culture in this country since 1965, the same concern animates our own White Paper. There are now many families for whom a trip to the theatre, a historic house, or a museum is second nature. But this is far from universal. Many of our institutions do great work in this area. But the challenge is to make that work sustainable, to make the engagement permanent, and to really try and reach those who are the hardest to reach.' [5]

Art is often, quite rightly, political. Long before a formal arts funding structure was put in place at the end of the Second World War, artists used their art to espouse viewpoints contrary to those of the government of the day. The creative freedom of artists is of paramount importance. It's one of the reasons it's so important for the Arts Council to operate at arm's length from the government.

In practice, over the years there has been a surprising degree of political consensus about the value of art and culture. True, politicians may not agree on what constitutes great art and culture, nor on what the role of art and culture should be in society, but neither do most artists. Keynes was a Liberal, Lee was Labour and Osborne and Vaizey Conservatives – but all recognised the value of public investment in art and culture.

5 https://www.gov.uk/government/speeches/ed-vaizey-culture-white-paper-launch

Nonetheless, when budgets have come under pressure at a national and local level, there has been a tendency for arts and culture to be viewed as 'nice to have', rather than a necessity. I hope that this perception is changing. Certainly, George Osborne's description of art and culture did not portray them as an optional luxury but as essential parts of the economic mixture – and significant catalysts for positive change and growth. which one is that

In this book, I argue that any reductions in investment will undermine this essential work in the places where it is most needed. This is important both at national and local funding levels. Local authorities have a crucial role to play in building and supporting the cultural ecology and physical infrastructure. They are the Arts Council's major funding partners, and the withdrawal of their support leaves a hole in funding that cannot be filled.

Even at times when funding is tight – and it is tight for councils across England at the moment – the most effective local authority leaders and chief executives are working alongside the Arts Council and other national funding bodies to ensure that arts and culture continue to be a part of their core strategy, bringing creative energy and vigour to their communities. It's what makes them great places to live, work and do business.

" The creative freedom of artists is of paramount importance. It's one of the reasons it's so important for the Arts Council to operate at arm's length from the government. "

Ideally, artists, arts organisations, museums, libraries and our creative industries should have a valued place in policy and decision making in Whitehall – and in town halls, city halls and county halls.

Investing in the next generation

The UK's status as a creative nation is sometimes better recognised abroad than at home, though in recent years there has been greater understanding of the economic value of the creative industries to 'UK plc'. Our future success depends upon a sustained supply of national talent. We need to identify, nurture and develop this talent from an early age. *root of putting in out-*

ARTS EDUCATION

So, providing children and young people with the highest quality cultural education is vitally important. Every child should be able to enjoy great art and culture for its own sake. School subjects such as art and design, dance, drama and music should not be seen as entertaining optional extras. They give young people knowledge and skills that will help them build careers that are creatively and economically valuable.

Some will go on to study at our excellent network of conservatoires or arts universities and will work in the cultural sector or creative industries. Many will take jobs in other sectors – but they will do so as more rounded and confident human beings, because art and culture has been a strong part of their education.

Outside the classroom, children and young people should have the opportunity for their lives to be enriched by the performing

arts, by museums, galleries and libraries. They should take part in creating new art and culture, and they should be encouraged to experience the very best that is on offer. This should be the same for all children, no matter where they begin in life. Every child should have the opportunity to realise his or her talent, whoever they are and wherever they live. They should not be disadvantaged by the colour of their skin, their religion, their family background, gender, sexuality, disabilities, geographical location or a lack of money.

We need talent, of every sort. And to get it, we will have to break down the barriers that block young creative talent from flourishing and build bridges that allow that talent to proceed and succeed.

I will talk about this in detail in Chapters 1 and 2, because it is so important. The development of the next generation of creative talent should be a priority for those who care about the future of art and culture in this country.

Art is valuable in itself

It's important to underline that there are a multitude of intrinsic benefits that come from being surrounded by quality artistic and cultural events and experiences – and from simply being involved in the process of creating something. Paintings, sculptures, photographs, dance, drama, music, literature, poetry, carnivals, parades, crafts, digitally created art – all of these bring profound pleasure on an individual and collective level.

Great art can transport us to a different place. It can take us from the mundane realities of life to a new world. It can fire our imagination and show us the possibilities of other lives, other places – even other galaxies. It can lead us to question ideas and it can challenge our assumptions.

For me, more than anything, the best art is always provocative. It always gets my attention – and a suitable reaction. I love it; I dislike it; it perplexes me; or it shocks me. It stimulates an emotional response.

What is the Arts Dividend??

This book talks about the Arts Dividend – the great benefits art and culture confer on our society. But art that is not engaging or pleasurable or cannot be enjoyed for its own sake, is scarcely likely to have much of an impact in other ways. So we must always celebrate the intrinsic value of art as a human, emotional, transformative experience. That experience in itself is a reason for investing in art and culture. But it's not the only reason.

Artistic and cultural activities can produce a wide variety of outcomes, beyond purely having an intrinsic value. This adds to the excitement and relevance of the art. For some great artists, it's an inspiration. As the sculptor Sir Antony Gormley (creator of *The Angel of the North*) put it:

> *'Maybe this is a utopian view of art but I do believe that art can function as a vehicle, that it isn't just a cultural pursuit, something that happens in art galleries. Unless art is linked to experience and the fear and joy of that, it becomes mere icing on the cake.'*

If you like, art can be used as a tool to secure a beneficial outcome – it is 'instrumental'. For me, there doesn't have to be a choice between instrumental and intrinsic benefits. I'd maintain that the best of art has the greatest value in every way. But it's important that we never think of investment in arts and culture solely as a tool. We should not invest in artists and cultural organisations only for instrumentalist purposes. Invest in quality and creative ambition and the other benefits will follow.

Different people will define outcomes in different ways, but for me, there are seven 'dividends' that flow from sustained investment in art and culture. In the seven chapters that follow, I'll look at each of them in turn.

It's not subsidy

Art and culture in Britain is funded by a network of public and private investment, including local authorities, central government, the National Lottery, higher education institutions, philanthropists, business sponsors, charitable foundations and the ticket-buying public. It's a structure that has evolved over time, and everyone participates because it works for them, one way or another. There's a long tradition of public and private arts funding in Britain, and

" *We must always celebrate the intrinsic value of art as a human, emotional, transformative experience.* "

these influences have helped shape the variety that's a character-
istic of our national culture.

These funders do not 'subsidise' the arts. It's never a one-sided
transaction in which one party gives for no return; there is always
a return, though it may not be immediately obvious or even accrue
to the original benefactor, and they may not expect it to. The
return may be in terms of the artistic experience, or the support of
creativity and talent. Or there may be a clear economic pay-back,
the promotion of a company's commercial interests, or an interest
in supporting the life of a community.

But there's no subsidy. Personally, I cannot abide the term. The
Arts Council doesn't use public money to subsidise art and cul-
ture – it invests public money for the benefit of all the public. I'll
be showing how this works. And I guarantee that in the rest of the
book, you won't see the word 'subsidy' used again.

the creativity dividend

in brief ...

(1) Creativity is at the heart of great art and culture, and it runs through all six of the other Arts Dividends that follow this chapter. Creativity changes a place and the people who live there for the better. Creative people are inventive, imaginative and innovative. They think differently and see and do things in new ways that remake the world around them. But to be a truly creative nation, we need to identify and nurture talented people from all parts of the community. Without a genuinely diverse talent base, creative possibilities will be capped and personal potential will remain unfulfilled.

The recipe for creativity

Creative people eat a lot of cake. And they bake a lot of cakes too. In my experience, they cook almost everything with great aplomb. Having spent so much time in the company of the widest imaginable range of artists and creators over the past twelve months, I can assert this with absolute confidence. My growing waistline is testament to the delicious homemade treats I have been served by the people I've met at arts venues up and down the country. I suppose it's obvious really. Creative people like creating things, so why should great food be an exception?

I believe that there is creativity embedded in all of us and that we could all be artists if we either wanted to apply that creativity, or if we knew how to do it. The broadcaster Andrew Marr summed up the creative disposition of human beings rather neatly in an article for the *New Statesman*:

> '*It's making. We are the making animal. Unless we make – that is, in some small way, change the world around us – we are not fully human. The making can be a book, a garden, cooked food, but the best making is the making of other human beings, kind and competent, through parenting, biological or otherwise. But what we do is, we change the world around us. We are because we make.*'[1]

I enjoyed one of my favourite meals of the past year sitting with a group of actors outside a National Trust barn on the cliffs

[1] http://www.newstatesman.com/culture/2015/01/andrew-marr-it-urge-create-makes-us-human

near Mevagissey one hot summer's evening. This is the home of Kneehigh, a remarkable theatre company that creates all of its new work in Cornwall, but has a reputation for innovation that has seen its productions grace stages not only all over the UK, but also around the globe. I was privileged to be allowed to sit in on their rehearsals for *946: The Amazing Story of Adolphus Tips*, an adaptation of a Michael Morpurgo book about the D-Day landings. It was to be premiered at 'The Asylum', Kneehigh's huge tent, pitched in a field at the wonderfully named Lost Gardens of Heligan just down the road from their rehearsal barns.

Besides what we might think of as conventional acting, Kneehigh is famous for using music and puppetry to tell its stories, and it was fascinating to be given an insight into their production process. I was struck by the camaraderie and warmth: everyone looked as though they were enjoying themselves – although they were in fact working incredibly hard. It was fun for me to watch, but there was deadly intent in the relentless rehearsing of lines, actions, songs and dances, all followed by feedback from the director Emma Rice (who, along with Michael Morpurgo, had also adapted the book for the stage).

This creative process, involving constant repetition with incremental minute improvements, is as much a part of science as it is of art. It's a technique embraced by great designers, such as Sir James Dyson, the inventor of the dual-cyclone vacuum cleaner. When they're working in inventing mode, engineers like Dyson don't expect to get everything right first time; but they know that the goal is worth pursuing, and so they try and try again, gradually

moving as close to creative perfection as they can. In his book *Black Box Thinking: The Surprising Truth About Success*, Matthew Syed discusses the ways in which initial failures in the creative process drive innovation. James Dyson shared his insights:

> *'People think of creativity as a mystical process. The idea is that creative insights emerge from the ether, through pure contempla-tion. This model conceives of innovation as something that happens to people, normally geniuses. But this could not be more wrong. Creativity is something that has to be worked at, and it has specific characteristics. Unless we understand how it happens, we will not improve our creativity, as a society or as a world.'* [2]

Watching rehearsals at the Kneehigh Barns, I realised I was wit-nessing one of the secrets of the theatre world – something special, that those not directly involved in a production rarely get to see. I was seeing something taking shape – creativity in action. It's a process of collaboration and it's only when you see it happening that you realise just how special, and how hard-won, it is.

A few years ago, when the designer Sir John Sorrell stood up to give a lecture at The Royal Institution, he handed out small red cards to the audience. On one side was printed the word 'Creativity' – the title of his lecture. On the other was the *Oxford English Dictionary* definition of the word:

[2] Syed, Matthew, *Black Box Thinking: The Surprising Truth About Success* (London: John Murray, 2015)

Bringing into existence.

Giving rise to.

Originating.

Being imaginative.

And inventive.

I have one of the cards stuck on the corner of my computer screen as I write these words. Producing this book is in itself a creative process; I find that little card a creative spur, as the ideas and words arise in my head and are shaped on the screen in front of me.

In 2014, John Sorrell returned to the subject of creativity in a book that he wrote with me and Paul Roberts – who, like John, is a leading thinker in the area of cultural education. In *The Virtuous Circle: Why Creativity and Cultural Education Count*, we argue that an excellent cultural education should be a universal right. It brings personal, social and commercial advantages that can benefit the lives of all individuals in society. I'll discuss the education dividends that investment in arts and culture pays back in the next chapter.

First, let's unpick creativity a little more. In many ways, the Creativity Dividend is the most important of all of the benefits that arise from art and culture. It's also the hardest to pin down and to quantify: but, like the lettering in a stick of Blackpool rock, it runs through each of the other six dividends.

Try to imagine a world devoid of creativity. It would be the antithesis of the ideas suggested by the words on John Sorrell's card: nothing would be brought into existence or given rise to; there would be no originating; and people would be neither imaginative nor inventive. In a world without creativity, we wouldn't be able to make improvements to the environment that we live in; we would not have the imagination or inventiveness to resolve the global issues that we all face in the twenty-first century.

To put it simply, creativity makes the world a better place. It enhances our lives. Through being creative in our approach, we can innovate – we can imagine a better future, and then realise it.

Sir John Hegarty made his name as one of the founders of the advertising agency Bartle Bogle Hegarty. His success in business was founded on his own creative ideas, but he was also able to spot creativity in other people, which helped him to surround himself with talent. Hegarty wrote that:

> *'Creativity touches all our lives in a thousand different ways, from the clothes we buy to the buildings we live in, from the food we eat to the cars we drive. Creativity invents, perfects, and defines our world. It explains and entertains us. Almost every facet of our lives is influenced by it. And its impact is only getting stronger as time goes on. It's not surprising then that we're always being told the future is creative!'* [3]

[3] Hegarty, John, *Hegarty on Creativity: There Are No Rules* (London: Thames & Hudson, 2014)

I have tackled the Creativity Dividend first in this book because it's often the most obvious outcome in the early stages of cultural investment. Great artists bring creativity with them when they roll into town, and that has an effect on everyone they come into contact with. This is not to overlook the enormously important and positive effects of home-grown artists engaging with the place where they were born or grew up. But I think that latent indigenous talent often comes to the fore when it's sparked by the arrival of new creative talent in a community. Artists of all sorts can very quickly alter how a town or city physically looks, and how the people there think of themselves and behave. I'll talk more about this in Chapter 5.

Artists can effect change in the most unlikely of places. This was brought home to me last summer, when I found myself eating (yet) another delicious supper with a community of artists. The meal had been prepared by Alan Lane, artistic director of Slung Low theatre company and we were in Slung Low's base, the Holbeck Underground Ballroom (known as 'The HUB'), just outside Leeds city centre.

It's not exactly a glitzy address, at least not in conventional showbiz terms. The HUB is made up of five railway arches in an area that

« Creativity makes the world a better place. It enhances our lives. Through being creative in our approach, we can innovate – we can imagine a better future, and then realise it. »

you might describe as being off the beaten track, artistically. But it is here that Alan and his team have built a home where they can dream up innovative and ambitious theatre. And, it would be fair to say, theatre that is sometimes slightly crazy too. But that's the brilliance of its beauty.

I watched Alan's production of *Camelot* at The Crucible in Sheffield, which involved the entire audience walking through the centre of the city on a Saturday night listening to the action on headsets, with explosions and artillery battles taking place in front of them. You assume you know the story of *Camelot*, but Slung Low's version was quite unlike anything I have seen. Alan Lane and the writer James Phillips had wholly reimagined it, turning it into a new piece of epic theatre.

The psychologist Mihaly Csikszentmihalyi notes that constant reimagination is the signature of the creative, across all artistic disciplines:

> *'Each poet, musician, or artist who leaves a mark must find a way to write, compose, or paint like no one has done before. So while the role of artists is an old one, the substance of what they do is unprecedented.'* [4]

Now, the logistics of having tanks roll through the streets of Sheffield on a Saturday night in the middle of summer, surrounded

[4] Csikszentmihalyi, Mihaly, *Creativity: The Psychology of Discovery and Invention* (London: HarperCollins, 1996)

by an army of 137 performers from Sheffield People's Theatre, while you act out a contemporary reworking of the Arthurian myths must be mind boggling. There must have been so many potential obstacles. But, working with the creative team at Sheffield Theatres, Slung Low had made it happen. To pull off a performance on this scale in Sheffield took exceptional application and dedication. Far from being a bunch of lazy luvvies, the best creative people demonstrate a greater entrepreneurial spirit and can-do approach than most of the rest of us. It's something that the BBC's Arts Editor Will Gompertz has noted:

> 'Artists don't seek permission to paint or write or act or sing, they just do it. What tends to set them apart, and gives them their power and purpose, is not their creativity per se – we all have that. Rather, it's the fact that they have found a focus for it, an area of interest that has fired their imagination and provided a vehicle for their talents.'[5]

I've seen this creative energy in many different cultural environments, not only in those we might think of as traditional arts organisations. Some libraries, for instance, currently face severe financial challenges because of reduced funding from local authorities – but, nonetheless, they continue to evolve and build on their historic role as storehouses of knowledge and information. Today, the very best of their number are creative spaces at the heart of their communities. I saw one good example at FabLab Devon, a small-scale digital fabrication workshop housed inside Exeter

[5] Gompertz, Will, *Think Like an Artist. . . and Lead a More Creative, Productive Life* (London: Penguin, 2015)

Library. It's an open-access, not-for-profit, community resource. It offers people the opportunity to develop new creative skills and learn how to free their own innate creativity – at FabLab, anybody can invent and make just about anything. It's a part of reimagining what the libraries of the future will look like.

Talent is everywhere: opportunity is not

I made my first speech as chief executive of Arts Council England at the Ferens Art Gallery in Hull. In 2017, it will be home to the Turner Prize – the same year in which Hull will assume the mantle of UK City of Culture. In that speech, one of the things that I talked about is the need for those involved in art and culture to do more to nurture creative talent across all of England, and for that creative talent to come from all parts of society. Nobody should be prevented from achieving their creative potential because of barriers of race, ethnicity, faith, disability, age, gender, sexuality, financial deprivation or geography.

Talent is everywhere; opportunity is not. Not yet. It's a problem, but one I'm determined to do something about.

I was particularly struck by a performance at Somerset House in London, at an event organised by the National Art & Design

The best creative people demonstrate a greater entrepreneurial spirit and can-do approach than most of the rest of us.

Saturday Club. This network of clubs – the brainchild of Sir John and Lady Frances Sorrell – offers young people aged between fourteen and sixteen the unique opportunity to study art and design every Saturday morning at their local college or university, for free.

I was speaking at the launch of the annual exhibition of their work, but I was completely overshadowed by the talents of the other speaker that night: twenty-four-year-old poet George Mpanga, who had been mentoring a group of Saturday Club members from Walthamstow.

George grew up on the St Raphael's Estate in north-west London before studying politics, psychology and sociology at King's College, Cambridge, where he began adapting his rap verses into poetry. Under the stage name George the Poet, he has a record deal with Island Records. The company's president, Darcus Beese, says of him:

> 'In this ever hyper-stimulated world, with attention spans decreasing by the minute, George asks us to slow down, listen, understand and hopefully act accordingly. Important stuff . . . there's not much more important than that.'

That night, George's recital of his poem 'All Existence is Contribution' was spellbinding – one of the most remarkable performances I saw in that first year at the Arts Council. It made my words seem quite inadequate, because his poem put the case so eloquently for the voices of all parts of our communities to be heard:

> *'Everyone brings something to the table*
> *But not everyone gets a seat.'* [6]

The poem calls for us to recognise the contribution young people from all backgrounds can make to society:

> *'Untapped potential could be unlocked ability*
> *Hidden wisdom, unsung possibility.*
> *We live in a world that celebrates our young*
> *For being more professional than clever.*
> *As a result, we miss out on a lot of knowledge*
> *At a time when it's more accessible than ever.'* [7]

I wanted to hear more. On the train home, I looked George up on the Internet and ordered a copy of his first collection of poetry *Search Party*. The anthology includes 'All Existence is Contribution' alongside another thirty or so of his poems. I urge you to read it.

But to make sure that we are liberating the creativity of every part of society, we need to have a more inclusive and diverse art and culture sector – and to achieve that we've got to make some fundamental changes. The arts need to reflect the world we live in – and shed light on the world we want to see. We need to understand – as many international businesses now do – that diversity is a major opportunity that we must embrace if we are to thrive. That's what

[6] George the Poet, 'All Existence is Contribution' from *Search Party* (London: Virgin Books, 2015)

[7] ibid.

the Arts Council is doing through promoting its Creative Case for Diversity. Rather than treating diversity as a kind of supplementary add on, or an activity that is supported to run parallel to the mainstream arts and culture world, the Creative Case presents it as being central to the creative process. It is an opportunity to find fresh ideas and new art.

When I talk about diversity here, I am referring to people who possess one or more of the personal characteristics that are protected under the law by the Equality Act of 2010. But I am also addressing the disparities of opportunity that arise through socio-economic and geographic factors. The promotion of diversity is about removing barriers that are faced by too many in our society.

At the same time as tackling disadvantage, it's important that we also celebrate everyone's diversity and the insight, experience and knowledge that people's diverse backgrounds bring to our national creativity. The more diverse we are as a community, the more creative we become. We need to ensure that the people involved at every level of the commissioning process are an accurate reflection of the way England looks and feels in the twenty-first century – those being commissioned, those doing the commissioning, and

It's important that we celebrate everyone's diversity and the insight, experience and knowledge that people's diverse backgrounds bring to our national creativity.

those funding it. That way we can make sure that the resultant art and culture is also properly representative.

It's an area of our work that has been championed by the chair of the Arts Council, Sir Peter Bazalgette. At the end of 2014 he launched the Creative Case for Diversity, setting out his vision for what needs to change over the next decade:

'If we make this work, diversity – and I'm talking ten years from now – will no longer be an aspiration. It will be a reality. Young talent, whatever its background or class will see the kind of work that convinces them that the arts belong to them – and that they have a way in. They will seek careers on the technical side; in administration; as performers; creators and, crucially, as leaders. If we do this properly, we'll have flourishing centres of creativity throughout our cities with work that inspires, enriches and broadens our horizons. Creative work that liberates the energy of our nation.' [8]

Having leadership role models who more accurately reflect our society is one of the key changes we need to make. After all, it's the people who lead arts organisations who are the ones making the creative decisions. They're deciding what to create and they're choosing who is going to create it. It's clear that we need a more diverse leadership across the arts and culture world, in our arts organisations, our museums and our libraries. The current leadership simply doesn't reflect the diversity of our nation and this

[8] http://www.artscouncil.org.uk/sites/default/files/download-file/Sir_Peter_Bazalgette_
Creative_Case_speech_8_Dec_2014.pdf

in turn is impacting on who is being commissioned. The onus is on all of us who are currently in positions of influence to ensure that the next generation of leadership talent is more reflective of our nation.

When I was in Bradford, I was left buzzing with excitement by my meeting with Syima Aslam and Irna Qureshi, the incredibly impressive double act behind the Bradford Literature Festival. It is the first literary festival in the UK that features programming for all communities, and it is led and curated by these two inspiring British Muslim women of Pakistani heritage.

With investment backing from Bradford University, Bradford Metropolitan District Council and Arts Council England plus significant financial sponsorship from Provident Financial Group, they have created a cultural and literary extravaganza that is already exceeding even their high expectations. They've succeeded in creating a literature festival designed for everyone in the city.

Just a couple of years after founding the festival, Syima and Irna are already developing international partnerships – from

" Having leadership role models who more accurately reflect our society is one of the key changes we need to make. After all, it's the people who lead arts organisations who are the ones making the creative decisions. "

collaborations in Japan around Yorkshire's own Brontë family, to a Sufi programme that takes in Pakistan and Turkey, to the presentation of a series of International Booker Prize events – all of which are designed to connect with and grow more diverse audiences on their home turf in Bradford.

A few weeks before my trip to Bradford I was at the Royal Exchange in Manchester – a theatre unlike any other I've seen. Originally it was a trading hall where, at the beginning of the twentieth century, some 80 per cent of the world's finished cotton was bought and sold. Today it is an attractive Grade II listed building, but walk through its front doors and you will find the cavernous old trading hall occupied by what appears to be a rather large spacecraft. In fact, this futuristic-looking structure houses the country's largest theatre in the round. I've caught a couple of productions there – and in both performances, I was pleased to see that rather than being all white, the casts were an accurate reflection of the life you'll see on the streets of Manchester. I had seen people from different races walking past a nearby café before the show, so why should it be any different on stage?

Actors should be cast on their talent. I thought that the author J.K. Rowling dealt with this brilliantly when questions were raised over the casting of the black actor Noma Dumezweni as Hermione in the new stage play *Harry Potter and the Cursed Child*. Of course, Dumezweni looks different from the white actor Emma Watson, who played the character in the seven films. Rowling, who let's not forget, actually created the character, put paid to the social media debate in one simple tweet:

'Canon: brown eyes, frizzy hair and very clever. White skin was never specified. Rowling loves black Hermione.' [9]

Of course, the colour of an actor's skin shouldn't be something that needs to be remarked upon here. But I believe I must, because there is still a long way to go in the creative industries to ensure that our workforce is sufficiently reflective of the way England looks today. I want us to reach a place where having diverse actors, writers and directors is literally unremarkable – simply a matter of course. We need to make sure that all people from all backgrounds are *included* in the creation of great art and culture. This was neatly encapsulated for me by the diversity consultant John Dyer in a presentation he gave at the No Boundaries conference at Manchester's new HOME arts complex in 2015:

'Diversity is inviting someone to a party. Inclusion is asking them to dance.' [10]

If we want to change and broaden the audiences for the arts and culture, we need to make sure that a significant proportion of the people who are making and fronting the artistic activities reflect the potential audiences that we are not reaching.

On stage → before audience

9 https://twitter.com/jk_rowling/status/678888094339366914?ref_src=twsrc%5Etfw

10 Dyer, John, Presentation to 'No Boundaries' conference. HOME, Manchester (30 September 2015)

In the autumn of 2015, I watched *The Etienne Sisters* at the Theatre Royal Stratford East, located in the heart of London's East End on the edge of the Olympic Park. This new play written by Ché Walker had a brilliant young all-female cast made up of Allyson Ava-Brown, Jennifer Saayeng, Nina Toussaint-White and Nikki Yeoh. Stratford East's artistic director Kerry Michael takes pride in the way that his theatre creates 'world class work that reflects the concerns, hopes and dreams of its community'. As I looked around the auditorium, I could see that by putting on stage an authentic story like *The Etienne Sisters* and presenting it with integrity, his theatre was truly connecting with the 'vibrant, young and diverse audience' targeted in his organisation's mission statement. The audience reflected the mix of people who live in Stratford. At that moment, I realised that getting diversity right isn't rocket science. Which makes it all the more perplexing that we haven't yet got it right.

Since taking over as the artistic director of another of London's excellent theatres – The Tricycle Theatre in Kilburn – Indhu Rubasingham has garnered rave reviews for her inclusive artistic programming. She is clear about why her strategy has paid dividends and why it should be more widely adopted:

> *'I believe that different, diverse stories are popular enough to attract all audiences and not just "new" ones and therefore they will make money. That is a pragmatic way to demonstrate the importance of diversity in our industry. Without that diversity we shall become mono-cultural, alienating and soon irrelevant. We need to take both small and large steps to ensure we encourage the best talent all around*

us. By this I mean we have as a whole ecology – across education, the arts and media – a responsibility to inspire, encourage and nurture talent where we least expect to find it. We need to be proactive, open and less fearful of taking risks. This will empower a diversity of tastes, a tapestry of stories, with ideas clashing, conflicting, collaborating – all of which is needed for our arts scene to be world-leading, rich, vital and relevant.'

Aside from the moral and creative arguments for diversity – which should be reasons enough – there are clear financial gains for arts organisations too. This was noted in the 2015 report by the Warwick Commission on the Future of Cultural Value:

'Diversity of creative talent and participation is essential to the expressive richness and the economic and social prosperity of the ecosystem. It is a mistake to think that the under-representation of Black, Asian and Minority Ethnic (BAME) individuals, women, deaf and disabled people and low-income groups in the Cultural and Creative Industries is purely a social justice issue.'[11]

Inclusion isn't just an issue in the theatre. The museum world has a big job to do in terms of the diversity of its workforce, so when I toured the Black Cultural Archives in Brixton, it was good to learn of their training programme, which has seen young people from BAME backgrounds go on to further education to train as professional museum curators. The classical music world arguably

[11] Warwick Commission on the Future of Cultural Value, 'Enriching Britain: Culture, Creativity and Growth', University of Warwick (2015)

has an even greater challenge when it comes to having a diverse workforce. The nascent Chineke Orchestra set up by Chi-chi Nwanoku, principal double bass player with the Orchestra of the Age of Enlightenment, in order to develop more diversity among orchestral classical music performers, is a welcome start.

There's still a long way to go to ensure that deaf and disabled people are also properly represented in our creative industries. Organisations such as London-based Shape Arts, which celebrates its fortieth anniversary in 2016, pioneered much of the thinking and action that has resulted in the greater inclusion of disabled artists alongside non-disabled people in arts organisations such as the Royal Opera House, National Theatre, Tate and the Southbank Centre. But there remains much more to do, if we are to bring disabled artists into the mainstream of all arts and culture organisations.

Ultimately, we have to recognise that it is the prevailing attitude within society itself that creates barriers to change, not those who are perceived as disabled. We need to start talking about 'enabled' rather than 'disabled' people in arts and culture. This is another important way in which creativity can be freed and through which we can make England a more creative place.

There's still a long way to go to ensure that deaf and disabled people are properly represented in our creative industries.

That's why I am particularly excited by Ramps on the Moon, an ambitious new theatre project launched in 2015, with £2.3 million of Arts Council funding. It's the largest investment made by Arts Council England in any project in its Strategic Touring Programme. It involves the New Wolsey Theatre in Ipswich, Birmingham Repertory Theatre, Theatre Royal Stratford East, Nottingham Playhouse, West Yorkshire Playhouse and Sheffield Theatres. All are working with Graeae Theatre, a company that has made its name by providing a platform for deaf and disabled talent by unambiguously placing disabled artists centre stage.

This new project will create a series of new pieces of high-quality touring theatre. Disabled people are at the heart of the work. Access is built into the fabric of the creative process, whether working with sign performers, animating screen projections or incorporating live audio descriptions. Each venue will co-produce shows over consecutive years, giving all the organisations direct experience of working with disabled artists and of learning how to develop disabled audiences. This will help each theatre to understand more about ways of including disabled people in everything they do in the future, creating a collaborative circuit of regional theatres and tackling the current low levels of attendance by disabled audiences.

I'm hoping that Ramps on the Moon will be just the start of a major movement to bring a far greater number of talented disabled actors into the mainstream theatre world. I also hope that the learning from the programme will quickly be transferred into other art forms alongside the theatre.

Although we may have a long way to go, there are nonetheless beacons of excellent practice across many art forms – including the visual arts and music. There is some great thinking and practice, for example, emanating from Intoart in Brixton. This visual arts charity helps adults and young people with learning disabilities to establish themselves as artists whose work is taken just as seriously as that by artists who do not have learning disabilities. I urge you to look out for their regular exhibitions at some of London's most significant private and public galleries.

When I was in Bristol recently, I was excited to learn more about the work of the British ParaOrchestra, the world's first professional orchestra for disabled musicians, which was founded in 2012 by the conductor Charles Hazlewood and is based at the city's At-Bristol Science Centre. Hazlewood is evangelical about the importance of the orchestra's work:

'I conduct orchestras around the world, and I can count on the fingers of one hand the number of musicians with a disability I have encountered anywhere. There is no platform for musicians with disability, very little in the way of funding – and therefore access to the often-necessary technologies: it is virtually impossible for anyone from this community to make a living as a professional musician.'

" We need to start talking about 'enabled' rather than 'disabled' people in arts and culture. "

Bristol is becoming something of a trailblazer in this important area, as it's also home to OpenUp Music, a community interest company that creates musical instruments playable with any part of the body, including the eyes. This is transformative, particularly for many young people with special educational needs. When I saw a performance by one of their Open School Orchestras in Bristol, I was impressed both by the music, and by the opportunity it gave young musicians with disabilities to explore and develop their musical experience. The team at OpenUp are helping to raise aspirations for young people with disabilities, and are showing how exciting it can be when music education projects are made accessible to everyone. They have now set up the South-West Open Youth Orchestra, the UK's only disabled-led regional youth orchestra, which is delivered in partnership with musicians from the British ParaOrchestra. It's an area of work that I hope will really grow over the coming years.

The lack of deaf and disabled talent on our stages really came home to me when I was at Warwick Arts Centre watching a performance of *The Deranged Marriage* – a very funny play written and directed by Pravesh Kumar and produced by the British Asian theatre company Rifco. One of the characters just happens to be deaf and he communicates with his brother using sign language throughout the play. Nobody on stage mentions it and it's not part of the plot. It just happens that he is deaf – in the same way that some people we meet in real life just happen to be deaf. It was unremarkable. I loved *The Deranged Marriage* anyway. But I loved it even more for that – for reminding me what life is like.

the learning dividend

in brief ...

Investment in cultural education will deliver long-term dividends to the UK's talent pipeline. Studying cultural education subjects such as Art and Design, Dance, Drama and Music in the classroom should be a part of every child's education throughout their schooling. They should also have opportunities to take part in formal and informal cultural education activities outside the classroom. The benefits of a sound cultural education are wide ranging, developing a child's knowledge, understanding and skills. We need to ensure that there is enough investment in place to make high-quality cultural education a part of every child's life no matter what their background – only then will the full benefits of this dividend be realised.

The children are our future

As I've travelled around the country, I have held scores of round-tables with artists and leaders of arts and culture organisations. I've never counted them up exactly, but I reckon that in one way or another, I must have had conversations with upwards of 5,000 people all over England during my first year at the Arts Council.

One of the most interesting and thought-provoking discussions I enjoyed was at the University of Kent's Gulbenkian Theatre, perched high on a hill overlooking the cathedral city of Canterbury. It's home to ART31, a new arts movement for anyone aged between thirteen and twenty-five. With the aim of showing just how much young people can achieve for themselves, the members of ART31 are encouraged to decide what events they would like to create and then to make them happen. Along the way, they pick up valuable skills as arts practitioners and technicians – and learn about how arts policy is shaped. Their name comes from Article 31 of the United Nations Convention on the Rights of the Child, which states:

> *'Children have the right to relax and play, and to join in a wide range of cultural, artistic and other recreational activities.'*[1]

The ART31 members told me about the importance that studying curriculum arts subjects at school, college or university had in their lives, both in terms of preparing them for future careers and in giving them valuable skills that they put to good use in other areas.

[1] http://www.unicef.org/crc/files/Rights_overview.pdf

Attending ART31 at the Gulbenkian was, for many of them, the highlight of their week and they told me how they planned their many other school commitments around their artistic activities.

Bright, articulate, challenging, thoughtful; these young people wanted to be sure that funders like the Arts Council would be investing in arts and culture that was relevant to their lives. They wanted to be certain that we understood the newest technology and how people in their teens and twenties used that technology to connect with and enjoy cultural activities. And they were very clear about the importance of studying arts subjects in schools. They regarded it as an absolute right rather than a privilege. It reminded me of a story that the artist Howard Ikemoto told about his daughter:

> 'When my daughter was about seven years old, she asked me one day what I did at work. I told her I worked at the college – that my job was to teach people how to draw. She stared back at me, incredulous, and said, "You mean they forget?"' [2]

With the clarity that only a child can possess, Ikemoto's young daughter had realised for herself that creativity is embedded in all of us. But her father's job working with students was about taking that creativity further. We need to be taught how to develop and hone our creative skills and this requires investment – of time, of

[2] Bayles, David and Orland, Ted, *Art & Fear: Observations on the Perils (and Rewards) of Artmaking* (Eugene, OR: Image Continuum, 1993)

money and of expertise. It all starts with investment in children and young people and in their cultural education.

right investment → benefits

When we make the right investment in art and culture, at the right time in childhood, we reap the second of our benefits – the Learning Dividend. And it pays back long after that young person ceases to be a child, with a multitude of further related dividends throughout their adult life.

Some young people will learn about art and culture – how to create it, enjoy it and appreciate it – and it will enrich their lives intrinsically, as discussed in the previous chapter. Others will learn skills that they will put to good use in whatever walk of life they end up pursuing. Some, meanwhile, will end up with careers that directly utilise their learning from studying cultural education subjects. All three outcomes are equally as valid, but they can only be outcomes if cultural education actually forms part of a young person's life.

Let me be unambiguous here: every child should benefit from the opportunity to study cultural education subjects to a high level in the classroom throughout their schooling. In addition, they should have access to a rich and varied set of opportunities to enjoy artistic and cultural activities outside of the classroom. Some of their cultural education should be formal; some informal.

❝ When we make the right investment in art and culture, at the right time in childhood, we reap the second of our benefits – the Learning Dividend. ❞

All children should be offered high-quality opportunities in school
and out of school.

learning = education = knowledge

The Learning Dividend could just as easily be labelled the
'Education Dividend' or even the 'Knowledge Dividend'. Learning
spreads across a lifetime, but in my mind, the most important time
for cultural learning is during childhood. Cultural education is
a key that can unlock the whole of a human being's future. And
properly resourced, high-quality cultural education is central to
helping a young person discover the possibilities of what they can
achieve in their future life.

As the director of the Tate, Sir Nicholas Serota, puts it:

> *'Public investment creates the nursery for our success and future
> generations will not forgive us if we fail to plant the seed for the next
> crop.'* [3]

It's not an accident that the UK has seen its creative industries
grow at a rate of 8.9 per cent between 2013 and 2014. That's faster
than any other industrial sector – including financial services. [4] It's
precisely because of a sustained investment in the talent pipeline
over the past twenty years that we are reaping the benefits now.
It's vitally important that we continue to invest more – not less –
in children and young people's creative and cultural education.

[3] 'How Public Investment in Arts Contributes to Growth in the Creative Industries', Creative
Industries Federation (2015)

[4] 'Creative Industries Economic Estimates', Department for Culture, Media and Sport
(January 2015)

That's the only way to make sure that our creative industries remain such a successful growth area.

The value of cultural education in schools has been recognised by the Secretary of State for Culture, Media and Sport, John Whittingdale, as a key driver of the growth in our creative industries:

> *'If this is to continue – and I am passionately committed to ensuring it does – we need to make sure we are nurturing the next generation of creative talent in order to guarantee our continued success. I believe strongly that every child should experience a high-quality creative and cultural education throughout their time at school. By encouraging children and young people to understand, appreciate and engage with the incredible wealth of creativity and culture that this nation has, we can help nurture the next generation of writers, artists, actors, games designers and musicians.'* [5]

To make these excellent aspirations a reality, we should now be creating an education framework that encourages more young people to study subjects such as Art and Design, Dance, Drama and Music at GCSE alongside English, Maths, Science and Languages. We need to ensure that the young people leaving our schools are fully rounded individuals, who are creatively equipped for the world of work. We must have an education system that opens the doors of possibility to our young people, rather than shutting down their options too early by forcing them to take a

[5] http://www.huffingtonpost.co.uk/john-whittingdale/creative-industries-economy_b_9078982.html

narrow set of subject choices that excludes these important aspects of cultural education.

The benefits of cultural education

The benefits of investment in cultural education aren't only there for us to see in economic terms – something that I will return to in Chapter 6. The Learning Dividend has huge benefits for society as a whole. Over the past decade, there has been a good deal of research into how engagement with arts and culture has a positive effect on young people's educational attainment, as well as how it improves outcomes later on in their lives. The Department for Culture, Media and Sport's 'Culture and Sport Evidence' programme (CASE) published two reports on the subject. These concluded that learning through arts and culture improves pupils' attainment across many parts of the school curriculum, as well as having other benefits for young learners.[6] The conclusions were summarised by Arts Council England in 2014 in 'The Value of Arts and Culture to People and Society'. They show that:

- *Taking part in drama and library activities improves attainment in literacy.*

- *Taking part in structured music activities improves attainment in maths, early language acquisition and early literacy.*

[6] The Culture and Sport Evidence programme: 'Understanding the Drivers, Impact and Value of Engagement in Culture and Sport', Department for Culture, Media and Sport (2010) and 'Understanding the Impact of Engagement in Culture and Sport: A Systematic Review of the Learning Impacts for Young People', Department for Culture, Media and Sport (2010)

- *Schools that integrate arts across the curriculum in the US have shown consistently higher average reading and mathematics scores compared to similar schools that do not.*

- *Participation in structured arts activities increases cognitive abilities.*

- *Students from low income families who take part in arts activities at school are three times more likely to get a degree than children from low income families that do not engage in arts activities at school.*

- *Employability of students who study art subjects is higher and they are more likely to stay in employment.*

- *Students who engage in the arts at school are twice as likely to volunteer than students who do not engage in arts and are 20 per cent more likely to vote as young adults.[7]*

So what do we mean by cultural education?

Cultural education spans a wide brief and there is no universal definition of exactly what it encompasses. For the purposes of this book, I consider cultural education to include: archaeology, architecture and the built environment, archives, craft, dance, design, digital arts, drama and theatre, film and cinemas, galleries, heritage, history, libraries, literature, live performances, museums, music, poetry and the visual arts.

[7] 'The Value of Arts and Culture to People and Society', Arts Council England (2014)

In *The Virtuous Circle*, our book about the benefits of creativity and cultural education, John Sorrell, Paul Roberts and I identify four elements of cultural education. The first is knowledge-based and teaches children about the best of what has been created (for example, great literature, art, architecture, film, music and drama). It introduces young people to a broader range of cultural thought and creativity than they would be likely to encounter in their lives outside school. The second part of cultural education centres on the development of analytical and critical skills, which can also be applied across other subjects. The third element is skills-based and enables children to participate in and create new culture for themselves (for example designing a product, drawing, composing music, choreographing a production, performing rap poetry or making a short film). And the fourth element centres on the development of an individual's personal creativity, which I discussed in the previous chapter.

It's not automatic that every child will make an instant connection with every art form. The leading educationalist Sir Ken Robinson underlines the need for young people to be taken on a journey of discovery for them to gain the most from cultural education:

> *'When people find their medium, they discover their real creative strengths and come into their own. Helping people to connect with their personal creative capacities is the surest way to release the best they have to offer.'*[8]

[8] Robinson, Ken, *Out of Our Minds: Learning to be Creative* (Chichester: Capstone, 2011)

And the psychologist Mihaly Csikszentmihalyi agrees that creative achievements don't usually come about because of a moment of genius. Instead they are the result of a hard slog, of the dedicated learning of a craft:

> *'Most creative achievements are part of a long-term commitment to a domain of interest that starts somewhere in childhood, proceeds through schools, and continues in university, a research laboratory, an artist's studio, a writer's garret, or a business corporation.'* [9]

The author Malcolm Gladwell popularised this idea in his 2008 international bestseller *Outliers: The Story of Success*. Drawing on research by a Swedish academic, Gladwell talked about the so-called '10,000 Hour Rule', suggesting that to become a true expert in any skill often requires practising in the right way for a total of around 10,000 hours. In the area of cultural education subjects, the need to learn and discover through practice suggests that there is much merit to Gladwell's argument. All the more reason for ensuring that our young people are given the opportunity to start practising early, so that they can reap the benefits of their skills later in life. If they don't start this learning while they are at school, they will have little chance of catching up with their contemporaries from rapidly developing countries around the world where creativity and creative subjects are prioritised in the education systems. There is a risk of our nation becoming competitively disadvantaged if we fail to prioritise them here.

[9] Csikszentmihalyi, Mihaly, *Creativity: The Psychology of Discovery and Invention* (New York: HarperCollins, 1996)

Cultural education subjects are sometimes dismissed as an easy option – suitable for the less gifted or able. This idea needs quashing straight away. Just as with every other facet of the education world, there is good cultural education and poor cultural education, but when taught well, subjects such as Art and Design, Dance, Drama and Music are every bit as rigorous an intellectual challenge as any other subject in the school curriculum – and often they are also physically challenging. I believe unequivocally that young people should be able to study these subjects at GCSE and beyond. Any narrowing of the curriculum, or squeezing out of cultural education subjects at this point in a child's school career risks damaging the talent pipeline for our creative industries – diminishing the number of young people with the skills that business leaders in these industries constantly tell us they are seeking. These are fast-growing industries, vital to the UK economy and we should not ignore their message about the type of talent that UK plc requires to stay ahead of the international game.

Passing on the baton — future .

As well as learning in the classroom, it's important for young people to be able to make a connection with the people who create the art and culture around them.

In my job, I am fortunate to talk to great artists on a regular basis. I met two particularly inspiring writers on the same day, when I gave a speech at the announcement of the new Waterstones Children's Laureate. Before the new name was revealed, I joined with the chief executive of Waterstones, James Daunt, in thanking the

outgoing Children's Laureate, the wonderful Malorie Blackman. In her two years in the role, she worked tirelessly to encourage young people all over the country to share her love of reading, books and libraries. Malorie handed over the baton to the brilliant illustrator and writer Chris Riddell, who will now hold the title until the middle of 2017. He's drawing his way through his tenure, posting a daily doodle on his website, charting his adventures in schools, libraries and bookshops around the country.

Malorie and Chris possess the magical ability to light a spark of creativity inside the young people that they encounter. It's a big part of being Children's Laureate.

One of the most important responsibilities of the Arts Council is to nurture and inspire the next generation of creative talent in our schools and colleges. We need to build that next generation of arts and culture audiences and practitioners, no matter what their background or where they live. Working with heroes like Malorie and Chris, who are so keen to share their personal creative talent with the next generation, makes that effort far more effective. The possibilities suddenly seem limitless – which is what creativity is all about.

Making new connections with young people isn't only the preserve of writers. Every year, just before Christmas, I make sure that I see a pantomime. This year, I caught *Alice in Wonderland* at the Customs House in South Shields – my first visit to see a show there. The dame is habitually played by Ray Spencer, who also co-writes the pantomime each year with Graeme Thompson, the dean

of Arts, Design and Media at the nearby University of Sunderland. When he's not donning outrageous wigs and dresses, Ray is also the executive director of the Customs House. As I looked around the packed auditorium, I saw people of all ages, and many multi-generational family groups. At the Customs House, there are also performances with sign language for deaf people and 'relaxed' performances, with gentler lighting and fewer loud noises, which are suitable for audiences with autism spectrum conditions, or who have other special needs. These tailored performances are now a common part of most pantomimes up and down the country, as are dedicated performances for schools.

So, here is an art form that is engaging on an equal level with people from all walks of life, young and old, with and without disabilities. In 2014, 2.7 million people enjoyed pantomimes at theatres in England – making it among the most truly diverse artistic activities in the country. Importantly, pantos get young people from all backgrounds into theatres. These children become used to being in cultural spaces and watching acting, singing and dancing on a stage. For some of these youngsters, who come from tougher economic environments, a school trip to the pantomime might well be their first visit to a place that has a stage and seats

❝ *As well as learning in the classroom, it's important for young people to be able to make a connection with the people who create the art and culture around them.* **❞**

that tip up. It will certainly open their eyes to a different world – and it could quite possibly change their lives.

In 2014, Arts Council England published 'Understanding the Value and Impacts of Cultural Experiences'. This report suggests that when people engage with a cultural activity – a pantomime performance, for example – the activity has three stages of impact. The first happens while the activity is actually going on. This is pretty obvious, given that the audience member will be watching and hearing something happen in front of them. The other two are less overt. Researchers have observed the second stage in the hours and days just after the artistic event, with effects including emotional and spiritual uplift and learning and critical reflection. The third stage can continue for weeks or even years after someone attends an arts event. The good news is that the benefits accrue over time. The more often people attend arts events, the bigger the cumulative impact of these events on their lives.[10]

Cultural education should start early in children's lives. We shouldn't be waiting for formal schooling to kick in before introducing playing music, dancing, acting, reading, writing, painting, drawing, building, making and creating into the lives of babies and toddlers. In her 2011 independent report for the government on early years provision, Dame Clare Tickell clearly lays out a rationale for delivering cultural education to the very youngest children:

[10] Carnworth, John D. and Brown, Alan S., 'Understanding the Value and Impacts of Cultural Experiences', Arts Council England (2014)

'Alongside the three prime areas of personal, social and emotional development, communication and language, and physical development, I propose four specific areas in which prime skills are applied: literacy, mathematics, expressive arts and design, and understanding the world. Practitioners working with the youngest children should focus on the prime areas, but also recognise that the foundations of all areas of learning are laid from birth – for example, literacy in the very early sharing of books, and mathematics through early experiences of quantity and spatial relationships. Any focus on the prime areas will be complemented and reinforced by learning in the specific areas, for example expressive arts is a key route through which children develop language and physical skills.'[11]

Music offers fine examples of a number of generations coming together to enjoy a creative activity. Nowhere has this been more apparent to me than at the brass band concerts that I've attended. Sometimes there are three generations performing together on stage – each player with a mutual respect for the incredibly high standards of musicianship exhibited by all the other members of the band, no matter what their age. And the standards of musicianship in the English brass band tradition are extraordinarily high. Many of the concerts take the form of competitively judged competitions, and playing in a brass band is a deadly serious business for those involved.

[11] Tickell, Clare, 'The Early Years: Foundations for Life, Health and Learning', Department for Education (2011)

The Great Northern Brass Arts Festival, which took place on an autumnal Saturday in 2015 at Manchester's Bridgewater Hall, sticks in my mind. There were terrific performances by the likes of The Fairey Band, who hail from just down the road in Stockport, and the Brighouse and Rastrick Brass Band from across the Pennines in West Yorkshire. Alongside these adult bands were young performers from the National Children's Brass Band of Great Britain and a group from a single school in Rochdale – the Wardle Academy – whose playing was so terrific that it almost lifted the roof off the Bridgewater Hall.

If ever you have any doubt about the standards of musicianship that can be reached by young people, then book a seat at the Music For Youth Schools Prom, which runs every November at London's Royal Albert Hall. The performances from right across the music spectrum are quite outstanding – from classical to rock, choral to jazz, brass to folk.

And if you have fundamental doubts about the way in which cultural education can change young lives, then look out for a performance by Liverpool's West Everton Children's Orchestra, which is based at St Faith's Primary School in one of England's most economically disadvantaged communities. The area is being transformed under the leadership of musicians and education specialists from the Royal Liverpool Philharmonic Orchestra.

The West Everton Children's Orchestra is one of six 'In Harmony' programmes in England funded by the Department for Education and the Arts Council. Inspired by 'El Sistema' (the famous publicly

financed music education programme in Venezuela) the project inspires children and their families through music by encouraging the whole school (including the teachers and, in St Faith's case, the lollipop man) to form an orchestra. The results have been profound.

Since the programme began, St Faith's has seen significant increases in children's educational attainment in reading and numeracy. And there have been improvements in self-esteem, confidence, pride and wellbeing. Not only are the children learning music for four and a half hours a week in curriculum time, but, when after-school activities are also taken into account, two thirds of them are spending as much as a total of ten hours a week learning music.

I've seen the West Everton Children's Orchestra performing both in their school and in front of a packed audience at Liverpool's Philharmonic Hall. The latter remains one of the most moving orchestral concerts I've witnessed – making the impact of the programme so much more obvious than any of the impressive statistics quoted above. You can see it in the concentration, dedication and discipline as the children perform. And then in the broad smiles on their faces as they take their bows to rapturous applause at the end of the concert. I'm not the only one with a soft spot for the programme. As the *Guardian*'s Tom Service wrote:

'I saw the government's "In Harmony" scheme in action in Liverpool and what an astonishing, inspiring experience it was... seeing it in

action is the sort of experience that would make a music-educational
evangelist of any politician.' [12]

The dance education on offer in England is just as exciting as that
in the world of music. Organisations such as The Place, home
to the London Contemporary Dance School, are pioneering the
provision of high quality training to the next generation of dancers
and choreographers. And I defy anyone to watch a performance
by the Sadler's Wells-based National Youth Dance Company and
not to be thrilled and energised by the onstage accomplishments of
the teenage dancers from all over the country who come together
to create and tour a major new dance piece each year.

And remember, cultural education helps to achieve all this – and
in the course of it, provides jobs in our fastest-growing sector. As
Damon Buffini, the chair of the National Theatre and a founding
partner of the global investment company Permira says:

'Cutting edge creative industries are hungry for talent and ideas.
Britain has both and it is in no small part due to our investment in
the arts over the last half-century – in schools, in universities and
through public funding for visual and performing arts.' [13]

There really are jobs out there for young people whose talent
has been identified and nurtured. Some of the young people who
take cultural education subjects at school will go on to study at

[12] Service, Tom, 'Why the In Harmony project rings true', *Guardian* (30 September 2009)

[13] 'How Public Investment in Arts Contributes to Growth in the Creative Industries', Creative
Industries Federation (2015)

specialist conservatoires or arts institutions such as the Royal Northern College of Music in Manchester, the Northern School of Contemporary Dance in Leeds or one of the specialist colleges that together make up the University of the Arts London, such as the London College of Communication, the London College of Fashion and Central Saint Martins.

Just take a look at the *Independent*'s list of the top ten UK universities from where you're most likely to get a graduate job, along with their graduate employment rate:

1. Royal College of Music, London – 100%

2. Trinity Laban Conservatoire of Music and Dance – 99.1%

3. Royal Agricultural University, Cirencester – 98.2%

4. Bishop Gosseteste University, Lincoln – 98.1%

5. University of Buckingham – 98.1%

6. Royal Conservatoire of Scotland, Glasgow – 98%

7. Royal Northern College of Music, Manchester – 97.8%

8. Arts University Bournemouth – 97.4%

9. Courtauld Institute of Art, London – 97.3%

10. Robert Gordon University, Aberdeen – 97.2% [14]

[14] Ali, Aftab, 'Exam Results 2015: Top 10 UK universities where you're most likely to get a graduate job from', *Independent* (18 August 2015)

Six of them are specialist arts institutions – proof again of the Learning Dividend we gain from investment in arts and culture, and investment in cultural education in particular. But these universities are not only important because they add to the talent pipeline, they also play a significant role in helping to frame the cultural world of the future into which that talent emerges. The vice-chancellor of the University for the Creative Arts, Professor Simon Ofield-Kerr, believes that it is the ability of these higher education institutions to focus so specifically on a particular area that makes them so successful:

'UCA is special because it's specialist – a community that is entirely focussed on learning, teaching and researching creativity. Crucially, however, it is our breadth within this specialism that really provides our creative project with the vitality so characteristic of the British art school. At UCA, film, acting and creative writing students study alongside one another, as do architects and fine artists, fashion designers, photographers and journalists. They work together on projects and in shared workshops, and it is this creating together, this meeting of minds and hands, that most fundamentally exemplifies the creative specialist's uniquely successful form of education.'

Although I believe that higher education institutions will play an increasingly important role as custodians and co-investors in our creative and cultural institutions in the coming years, university is by no means the only route into a job in the creative industries. A renewed focus on apprenticeships is starting to make a difference across the arts and culture sector. On my travels, I have met a range of impressive young apprentices starting out on their careers

in arts organisations, museums and libraries. I was struck by how well integrated into the day-to-day lives of their organisations the apprentices were, whether at the London Transport Museum, the Grundy Art Gallery in Blackpool or Hull Truck Theatre. Not only were they eagerly seizing the opportunity to learn about their chosen careers, but their organisations were benefiting from the insight that only a highly motivated, engaged teenager or twenty-something can bring.

The cultural education challenge

There's a lot of talent out there among young people – and the lucky ones are achieving great things with wonderful opportunities such as performing at the Schools Proms at the Royal Albert Hall. Others, like the children of West Everton, are being given equally wonderful opportunities to start their cultural education journeys closer to where they live. But we need to make sure that all of the young creative talent in England is getting the chance to achieve great things. It's only then that the Learning Dividend will pay out for all of our young people – and for society as a whole.

Often those parents who can afford to do so (and who realise the importance of cultural education) improve the opportunities for

❝ University is by no means the only route into a job in the creative industries. A renewed focus on apprenticeships is starting to make a difference across the arts and culture sector. ❞

their children by making a series of interventions in their lives. This might include taking them to ballet or drama lessons; encouraging them to play a range of musical instruments until they find one that they enjoy; visiting the theatre, the cinema, galleries and museums; having a library card and reading books for pleasure; or buying them arts materials so that they can make their own creations. This is, of course, a good thing but it means that young people who come from tougher economic backgrounds, where discretionary spend is tight, and where there may be no family experience of engaging with the arts or culture, are immediately at a huge disadvantage.

At the end of 2015 the Arts Council launched the Cultural Education Challenge. It's a national call to action designed to put the issue of cultural education back on the public agenda and to help ensure that all children and young people right across the country are provided with a coherent cultural education. The Arts Council identified nine key things that should form part of every child's school life, highlighted in these three statements:

- *Every child should be able to **create**, to **compose** and to **perform** in their own musical or artistic work.*

- *They should all be able to **visit**, to **experience** and to **participate** in extraordinary work.*

- *They should be able to **know** more, to **understand** more, and to **review** the experiences they've had.*

Cultural education needs to be of a high quality and to be available to those who currently have the least opportunity to enjoy it. There is startling evidence that those from the most educationally deprived backgrounds are least likely to engage with cultural activities, perpetuating a cycle of exclusion. It's a national tragedy that those talented young individuals are failing to achieve their potential. So we need a sustained long-term investment in talent that exists, not in short governmental funding cycles, but for a generation. That way we can know that a child born today can enjoy cultural education for the next twenty-five years of their life – through to and beyond the end of their studies.

The moral argument for the way that cultural education enriches children and young people is widely understood. But let's consider it from a commercial point of view. This country's greatest asset is its talent and it makes no business sense whatsoever to make such incomplete use of it. The Cultural Education Challenge is about changing this in meaningful, lasting ways. It seeks to bring together schools, higher education institutions, local authorities, central government, arts and heritage organisations, museums, libraries, charities, philanthropists and businesses in local areas so that they can share resources and create a series of Cultural Education Partnerships. An initial fifty such partnerships are being launched across the country but more will follow, as the challenge rolls out to new places. We are already seeing the positive results of this Learning Dividend in the pilot Cultural Education Partnerships established in Bristol, Great Yarmouth and Barking and Dagenham. I have no doubt that their successes will soon be mirrored in villages, towns and cities across the land.

the feel-good dividend

in brief ...

Scientific evidence shows that taking part in artistic and cultural activities can improve our health and wellbeing. Participating in arts and culture can make us feel happier and there are clear medical benefits in the treatment of a number of conditions. At a time when financial pressures on the National Health Service have never been greater, therapies involving arts activities and cultural venues offer a cost-effective alternative to drugs and other treatments. Indeed, in some cases, they have been proven to be more medically effective. There are a range of benefits in the arts and health sphere that are particularly notable in the lives of older people.

Health and wellbeing

On the days when I'm working in the Arts Council's London office, I walk from St Pancras International railway station along the Euston Road, past University College Hospital. Opened by the Queen in 2005, the building still looks relatively shiny and new. It might not be the most obvious place to find art and culture, but look through the windows and you will see a treasure trove of artworks hanging on the walls of the corridors. Now, I don't like hospitals at the best of times, but the presence of art always makes the building seem far less foreboding and clinical to me. On more than one occasion, I've stopped to look more closely through the window at a particularly enticing picture.

University College Hospital has its own curator, Guy Noble, who is responsible for managing the hospital's art collection. He also curates exhibitions, oversees music performances in the hospital and arranges artistic activities in which patients can take part. It's all paid for by charitable donations, or by artists loaning work to the hospital on a temporary basis. Sometimes Guy is able to commission new art and his tastes are ambitious, with works by the likes of Sir Peter Blake, Grayson Perry and Stuart Haygarth hanging on the hospital walls. He believes that art is an important part of life at University College Hospital:

> 'There is a growing body of evidence around the clinical benefits of the arts on both staff and patients within healthcare settings. However, in my eighteen years of experience it is the personal interactions and conversations which I encounter on a daily basis that convince me of

the importance of arts in hospitals. For instance, a father telephoned me about the pleasure he and his sick son took from the hospital's exhibition programme. The changing displays provided him with a reason to wheel his son from his bed to talk and share stories whilst looking at the pictures. These cherished trips to the hospital gallery helped them through some difficult times. I was also fortunate to witness a non-responsive patient suddenly smile as a result of a harpist playing by her bedside. This simple emotion brought tears to all those around her. Such anecdotes are not quantifiable within a medical sense but they do reveal how the arts can bring comfort in the most difficult of times and demonstrate how the arts can reach where medicine sometimes cannot.'

Investment in visual arts, music, craft, dance and drama in hospitals can all add to our third Arts Dividend, which centres around feeling good. It's most closely related to the Creativity and Learning Dividends described in Chapters 1 and 2 in that it directly relates to people rather than to places or organisations. But it's a separate development onwards from these two dividends and deserves to be highlighted in its own right.

The Feel-Good Dividend comes about when investment in art and culture results in improvements to our health and wellbeing. Sometimes these improvements can be quite specific – and distinctly medical in their nature – relating to a particular mental or physical health condition. On other occasions, the benefits of participating in art and cultural activities, either as a creator or as an audience member, are less health-specific and more about our general wellbeing.

Being around creativity in general; encountering a performance; seeing or hearing art and culture; taking part in a cultural activity – all of these activities can make us feel happy and relaxed. With the hectic lives we lead in twenty-first century Britain, happiness and relaxation are often hard to come by, so anything that can help to address this has to be a bonus. Arts Council England published new research in 2015, which ranked cultural activities and wellbeing:

> *'All arts and culture activities are significantly associated with happiness and relaxation after controlling for a range of other factors. The ranking of cultural activities in terms of positive effects on happiness is as follows:*

> *1. Theatre, dance, concerts*

> *2. Singing, performing*

> *3. Exhibitions, museums, libraries*

> *4. Hobbies, arts, crafts*

> *5. Listening to music*

> *6. Reading*

❝ *Investment in visual arts, music, craft, dance and drama in hospitals can all add to our third Arts Dividend, which centres around feeling good.* ❞

The ranking of cultural activities in terms of positive effects on feeling relaxed is as follows:

1. *Exhibitions, museums, libraries*

2. *Hobbies, arts, crafts*

3. *Theatre, dance, concerts*

4. *Singing, performing*

5. *Reading*

6. *Listening to music'*[1]

The National Alliance for Arts, Health and Wellbeing identifies five main areas of arts in health. The first is about the introduction of arts into the healthcare environment, such as the artworks displayed in the corridors and waiting rooms of University College Hospital. The second is about actually taking part in the arts through participatory programmes that enable patients to be creative themselves. The third centres on medical training, with many doctors now undertaking programmes that teach them about arts and health practice in their early years at medical school. The fourth is the use of arts therapy via registered therapists, which tends to take in drama, music and the visual arts as a means of working with a patient on a one-to-one basis. Music therapy is perhaps the most widely understood area of this work. I've seen some profoundly moving examples of it being used by charities

[1] Fujiwara, Daniel and MacKerron, George, 'Cultural Activities, Artforms and Wellbeing', Arts Council England (2015)

such as Nordoff Robbins to connect with severely disabled young people. Professor Helen Odell-Miller and the excellent team at Anglia Ruskin University's music department in Cambridge are leading the way in publishing groundbreaking research into the value of music therapy in effectively tackling a range of health-related challenges.

The fifth area is called 'arts on prescription', whereby medical practitioners prescribe arts and creative activities for patients. This is becoming particularly widespread for people with mental health illnesses and those suffering from social isolation. Often a programme of arts activities is prescribed alongside other medical interventions.[2] A fascinating research project is currently underway at University College London, looking at the value of 'Museums on Prescription'. This is based on what's known as 'social prescribing', which links people to sources of community support to improve their health and wellbeing. The project connects lonely older people at risk of social isolation to partner museums in central London and Kent.[3]

The ability of art and culture to improve our health and wellbeing is an area that has seen a good deal of academic research. Consequently it has become a more important sphere of interest for those who make public policy worldwide. Countries such as the UK, Australia, Canada, Norway, Sweden and the USA have all published significant reports on the subject in recent years.

[2] http://www.artshealthandwellbeing.org.uk

[3] https://www.ucl.ac.uk/museums/research/museumsonprescription

Arts Council England's 'The Value of Arts and Culture to People and Society' (2014) cites a report by the Scottish Government that showed:

'Those who had attended a cultural place or event in the previous twelve months were almost 60 per cent more likely to report good health compared to those who had not, and theatre-goers were almost 25 per cent more likely to report good health. Participation in a creative or cultural activity shows similar benefits: those who had done this were 38 per cent more likely to report good health compared to those who did not, but that figure rises to 62 per cent for those who participate in dance. Those who read for pleasure were also 33 per cent more likely to report good health. The findings are consistent with a growing body of population level studies on the impact of engagement in culture on key quality of life measures.' [4]

Dr Rebecca Gordon-Nesbitt from Manchester Metropolitan University published an extensive report in 2015, 'Exploring the Longitudinal Relationship Between Arts Engagement and Health', which analysed fifteen long-term studies and suggested that there was a meaningful relationship between engaging with the arts and people living longer with a better quality of life:

'These international studies collectively suggest that attending high-quality cultural events has a beneficial impact upon a range of chronic diseases over time. This includes cancer, heart disease, dementia and obesity, with an inevitable knock-on effect on life expectancy.

[4] 'The Value of Arts and Culture to People and Society', Arts Council England (2014)

Many possible reasons for this positive association are speculated upon by the researchers brought together in this report – from increased social capital to psycho-neuroimmunological responses – all of which are interrogated in detail. One of the most compelling potential explanations for any positive association observed between arts engagement and health comes from the field of epigenetics, specifically the idea that environmental enrichment (in this case, cultural activity) can cause certain harmful genes to be switched off, enabling health-protective effects to be communicated from one generation to the next.' [5]

Recognition of this field of healthcare remains relatively new, with the Nuffield Trust's conferences on arts and health in 1998 and 1999 seen as pivotal moments in this area of thinking. Many academics stress that much more research is needed. Nonetheless, there is growing acknowledgement that there is a health dividend to the arts. In 2013, the Royal Society for Public Health identified a series of benefits from bringing visual, performance and participatory arts into hospitals. They included:

'Decreased stress levels; decreases in anxiety and depression; improvements in clinical indicators such as blood pressure; decreased perception of pain; reduced drug consumption; and reduced length of stay.

In particular, music interventions in hospitals are showing increasingly strong evidence of beneficial effect on physical and psychological patient outcomes. In primary care, an early use of arts and health

[5] Gordon-Nesbitt, Dr Rebecca, 'Exploring the Longitudinal Relationship Between Arts Engagement and Health', Manchester Metropolitan University (2015)

activity was in social prescribing schemes, and this remains the basis for many interventions, particularly in the field of mental health.' [6]

The idea of GPs prescribing arts activities as an alternative to drugs or other therapies is certainly catching on. If you look just inside the front door of Liverpool's magnificent Central Library, for example, you will find a row of shelves of 'Books on Prescription', which doctors recommend to patients as part of their treatment.

All of this comes at a time when there is sustained pressure on NHS budgets and wide acknowledgement that preventative health-care is often a far more economically efficient use of health funding than waiting to pay out to treat a condition once it has taken hold on a patient. It does therefore seem possible that arts and culture related therapies could become a growing part of the healthcare on offer in this country. We now need to build on the existing excellent research to continue to prove the value of investment in this area of healthcare and the dividends returned on that investment.

Arts and older people

Although arts and culture have health and wellbeing benefits for people of all ages, it is worth pausing to underline the particular dividends for older people. An Arts Council England survey of people aged over sixty-five, undertaken by ComRes in 2015, showed that 76 per cent of older people said that arts and culture

[6] 'Arts, Health and Wellbeing Beyond the Millennium: How Far Have We Come in 15 Years?' Royal Society for Public Health (2013)

are important to making them feel happy. And 60 per cent of those questioned said that arts and culture are important to making them feel healthy.[7]

In 2015, I was shown around the University of Manchester's stunning Whitworth Gallery by its director Maria Balshaw. It had just reopened, fresh from a £15 million refurbishment. With its collections of fine art, contemporary art, textiles, prints, wallpaper and sculptures, the Whitworth must rank among the finest galleries in the world, unquestionably deserving its accolade as the Art Fund Museum of the Year 2015.

While I marvelled at much of the art on show in this magnificent building, it is the memory of a small exhibition downstairs that has stayed freshest in my mind. As part of the Whitworth's Age Friendly programme, a group of older men had curated a selection of objects from the Whitworth's collection, which were displayed alongside other items related to their lives. It was part of a sustained programme by the Whitworth to engage more meaningfully with men in their sixties and seventies, who were under-represented among the gallery's visitors. Their exhibition told a fascinating story.

The Whitworth's engagement manager, Ed Watts, became interested in researching older men's participation in cultural activities after noticing their relative absence from the gallery, in contrast with people of other ages. Funded by the Baring Foundation, his

[7] http://www.comres.co.uk/polls/arts-council-england-older-people-poll/

findings have been published as *A Handbook for Engagement with Older Men*. This useful little book offers insights to other cultural organisations wanting to encourage this group into their institutions, giving details of similar programmes in Glasgow, Rhyl, London, Gateshead and Belfast.

The medical world is also becoming more aware of the possibilities of what can be achieved through art and culture in older people's lives. Guidance from the National Institute for Health and Care Excellence (NICE) published at the end of 2015 recommends that the NHS should provide opportunities for older people to engage in creative group activities, including singing and arts and crafts. NICE says that these sorts of activities support independence and mental wellbeing.[8]

The Mental Health Foundation also published a report in 2011 showing that activities such as storytelling and visual arts had a positive benefit on the overall health of the people who took part in terms of their mental health, while more physical activities such as drama and dance helped improve physical health.[9]

In 2011, perhaps spurred on by the success of the BBC's *Strictly Come Dancing*, Bupa published a report that borrowed the programme's catchphrase 'keep dancing' as its title.[10] In the same year, Trinity Laban Conservatoire of Music and Dance published

[8] http://www.nice.org.uk/guidance/ng32

[9] 'An Evidence Review of the Impact of Participatory Arts on Older People', Mental Health Foundation (2011)

[10] 'Keep Dancing: The Health and Well-being Benefits of Dance for Older People', Bupa (2011)

'Dancing Towards Well-being in the Third Age'.[11] Both reports underline the benefits that dancing can have on older people's lives, with positive impacts reported for people suffering from arthritis, Parkinson's, dementia and depression. The Bupa report also highlights evidence that regular dancing has a relationship with preventing falls in older people because it can improve their body strength and balance. To younger readers, the risk of falling over may seem trivial, but it's a growing issue for gerontologists the world over. In his book *Being Mortal: Illness, Medicine and What Matters in the End*, Atul Gawande notes that every year 350,000 Americans fall and break a hip. Of these, 40 per cent end up in a nursing home and 20 per cent are never able to walk again.[12] Providing large-scale solutions that improve the lives of patients and reduce the financial costs to health services is a priority.

It's not only dancing that has a positive effect on people's lives. Research published in 2015 by the Sidney De Haan Centre for Arts and Health at Canterbury Christ Church University showed that singing improves people's mental health and wellbeing, including reducing anxiety, stress and depression.[13]

Professor Stephen Clift led the study into four community singing groups, which were established across West Kent and Medway, in

[11] 'Dancing Towards Well-being in the Third Age: Literature Review on the Impact of Dance on Health and Well-being Among Older People', Trinity Laban Conservatoire of Music and Dance (2011)

[12] Gawande, Atul, *Being Mortal: Illness, Medicine and What Matters in the End* (London: Profile Books, 2014)

[13] https://www.canterbury.ac.uk/news-centre/press-releases/2015/research-shows -singing-improves-mental-health-and-wellbeing.aspx

Chatham, Dartford, Maidstone and Sevenoaks:

> *'The participants reaped the same positive benefits of social inter-action and peer support offered through the singing groups, which helped to clinically improve their mental health conditions. Some of the benefits experienced by the participants included an increase in self-worth and self-confidence, a reduction in stress, an improvement in memory and concentration and a sense of inclusion.'*

The musicians of Bournemouth Symphony Orchestra are among the most widely travelled of any in the country, with a 'home patch' that stretches from Cornwall all the way along the south coast to Hampshire. They worked with researchers from Bournemouth University in a programme that used music to provide support and therapeutic relief to people living with dementia, and to their carers. Alongside the orchestra's musicians, patients and carers played music together, while taking part in research into dementia. The professionals taught the participants to play along; nobody was left out, no matter their level of musical skill. After ten weeks of workshops, everyone who took part in the programme gave a concert performance, which was by all accounts a very moving experience.

❝ *Regular dancing has a relationship with preventing falls in older people because it can improve their body strength and balance ... singing improves people's mental health and wellbeing, including reducing anxiety, stress and depression.* ❞

Professor Anthea Innes of Bournemouth University Dementia Institute says the programme has had positive outcomes for all the participants:

> *'Social inclusion and a sense of community was an important, but unexpected outcome for everyone that took part. Progression with musical learning was clear for some of the people with dementia, and this gave them a sense of achievement and increased their confidence. Carers also felt happier as a result of attending the sessions, which provided them with respite. They also reported improvements in their relationship with the person with dementia. Coming to the group gave them something to talk about and look forward to.'* [14]

In theatres such as the West Yorkshire Playhouse in Leeds, specific dementia-friendly performances are now held for many productions, while museums and libraries offer rich resources for benefiting people living with dementia and their carers. With the prediction of increasing levels of dementia as our population ages over the coming years, this is a field where the art and culture community has much to offer society as a whole.

Arts & kindness

One of the more intriguing conversations about art and culture that I've enjoyed over the past year was with Tina Corri and Tom Andrews, respectively the chief executive and the director

[14] White, Harry T., 'Breakthroughs in Bournemouth: how the BSO is providing relief for people with dementia', *Guardian* (22 June 2015)

of advocacy at the arts charity People United. I caught up with them, along with social psychology professor Dominic Abrams, in People United's small office on the University of Kent's campus in Canterbury.

The central thesis of People United fits more closely with the Feel-Good Dividend than it does with any of our other dividends, but it involves thinking beyond the more generally understood ways in which arts and culture can have a positive effect on our health and wellbeing. Tom, Tina and Dominic told me how they have been exploring the role that arts and creativity can play in bringing about a more caring society. In short, People United believes that the arts can promote kindness, and improve the world around us:

> *'In order for us to live well together in our increasingly interconnected and complex world we need to strengthen our capacity for empathy, compassion, friendship, social connection and concern for others, including future generations. Our definition of kindness is rooted in theories of "prosocial behaviour"; where altruism is "a motivational state with the ultimate goal of increasing another's welfare", and prosocial behaviour, is "an action that helps or benefits another person."'* [15]

They don't see 'kindness' as a wishy-washy word, instead describing it as 'muscular'. People United's argument is that kindness can grow through the arts via four themes (or 'mediators' to use the correct psychological term):

[15] Broadwood, J.; Bunting, C.; Andrews, T.; Abrams, D.; and Van de Vyver, J., 'Arts & Kindness', People United (2012)

*'**Emotions** – the arts can engage people's emotions directly and powerfully and in doing so can spark feelings, such as empathy, that are key for influencing kindness.*

***Connections** – arts experiences can bring people together and have the potential to create immediate strong connections between individuals and groups.*

***Learning** – the arts can create opportunities for people to learn from and about each other and the world.*

***Values** – many arts experiences involve a deep exploration of human values which are key to determining how people live together and behave towards each other.'*[16]

It's an attractive manifesto for social change through the arts. As well as conducting research, People United places artists in communities to put their thinking into action. This has included site-specific music and drama performances, interactive art installations, films, poetry and projects based wholly in schools. They describe their commissions as 'illuminating art and kindness through the creation of new participatory work'.

It's unquestionable that greater levels of altruism, tolerance, neighbourliness, concern for others and trust would make the world a better place, so People United might be onto something. It's another dividend that investment in art and culture can pay out to society as a whole.

[16] Broadwood, J.; Bunting, C.; Andrews, T.; Abrams, D. and Van de Vyver, J., 'Arts & Kindness', People United (2012)

the innovation dividend

in brief ...

New technology has changed the way in which many industries operate. The arts and culture world is no different. Technology enables us to create, distribute and market cultural products and services in new and exciting ways, many of which have yet to be imagined. Although many artists and cultural organisations have embraced technological advances, others have yet to seize the opportunities available to them. For those that don't, there is a risk that they may be left behind, becoming irrelevant to the audiences of the future, for whom digital content and devices are already a central part of life.

Digital disruption

When he was interviewed by Jeremy Paxman for the BBC's *Newsnight* in 1999, the rock superstar David Bowie made a prediction about the power of the Internet. At the time, most commentators had not cottoned on to the potential of the World Wide Web, but Bowie foresaw that it would become the defining medium of the early part of the twenty-first century:

> *'The Internet now carries the flag of being subversive and possibly rebellious and chaotic . . . I embrace the idea that there is a new demystification process going on between the artist and the audience . . . I don't think we've even seen the tip of the iceberg. I think the potential of what the Internet is going to do to society – both good and bad – is unimaginable . . . The state of content is going to be so different to anything that we can really envisage at the moment where the interplay between the user and the provider are so in simpatico that it's going to crash our ideas about what mediums are all about.'*[1]

Bowie's prediction was remarkably accurate. As an artist, he understood and was able to articulate the creative possibilities that the Internet offered him. Far from being rooted in traditional models for engaging with his audience and for creating and distributing his content, he embraced this uncharted territory.

Although I cannot claim to have any of David Bowie's technological foresight, I've always been a sucker for new gizmos and

[1] https://www.youtube.com/watch?v=FiK7s_0tGsg

gadgets, particularly those made by Apple. Some might say that this is just evidence of rampant consumerism on my part or some sort of desire for technological one-upmanship deep in my psyche, but I genuinely believe that Apple products have changed the way that I work for the better. They've made many aspects of my life more efficient, more effective, more fun and more environmentally sound.

The first generation iPad only came into being in April 2010, yet its effect has been huge on users in both the work and leisure parts of their lives. People in their early twenties have now had this sort of technology in their hands throughout their entire adult lives. Their mobile phone or tablet is their most important means of connection, and in an age of instant gratification, pretty much every sort of artistic and cultural content with which they might want to engage is only a few button clicks away.

This provides a huge opportunity for the arts and culture world – but it's a major challenge too. Digital pioneers talk about the power of technology to disrupt existing worlds. I saw a slide from an IBM presentation online the other day, which read:

The Digital Disruption Has Already Happened

- *World's largest taxi company owns no taxis (Uber)*

- *Largest accommodation provider owns no real estate (Airbnb)*

- *Largest phone companies own no telco infra (Skype, WeChat)*

- *World's most valuable retailer has no inventory (Alibaba)*

- *Most popular media owner creates no content (Facebook)*

- *Fastest growing banks have no actual money (SocietyOne)*

- *World's largest movie house owns no cinemas (Netflix)*

- *Largest software vendors don't write the apps (Apple and Google)*[2]

Entire sectors of the business world have already been disrupted by advances in digital technology and there is no reason to believe that those of us in the arts and culture sphere will be immune. We already have plenty of evidence for the huge changes that digital downloading of music has brought to the record industry, for example, and other art forms will not remain exempt from change. It's all about seizing the chance to embrace new technology in terms of creativity, allowing us to invent new previously unimagined creative entities. It's about how we run arts organisations, museums and libraries, harnessing technology so that we operate more efficient and effective cultural businesses – for example, by sharing and using data to improve the way we communicate with audiences. And it's about how we directly connect great art and culture to the end consumers. We're doing this in an increasingly noisy and crowded world, where arts and culture organisations jostle for attention with a myriad other products and services.

It's by getting this right that we bring the Innovation Dividend into play. The Warwick Commission on the Future of Cultural Value acknowledged the effect that innovation is having on arts and culture in this country:

[2] http://www.ibmforentrepreneurs.com

'The digital revolution is transforming culture, just as it is transforming other aspects of our lives. It has increased levels of participation in informal cultural and creative activities, created new networks and forms of interaction, transformed the production and distribution of established art forms and allowed new art forms to emerge.' [3]

When art and tech join together

It's easy to dismiss technology companies as being a million miles removed from traditional cultural organisations, such as museums, galleries, libraries, theatres, or music venues. But for technology entrepreneur Baroness Martha Lane-Fox, the connection between the two is clear:

'People don't always recognise the link between the technology sector and the UK's public arts. But to be a great coder you need to be as creative as a poet or a designer. It is precisely this parallel which has encouraged me to not only advocate for the technology sector, including coding in schools, but to work with the Design Council and the Women's Prize for Fiction, advocating for creativity across the board. When we inspire each other we end up with a stronger society as well as a stronger economy, and having public organisations is an important part of that puzzle.' [4]

[3] Warwick Commission on the Future of Cultural Value, 'Enriching Britain: Culture, Creativity and Growth', University of Warwick (2015)

[4] 'How Public Investment in Arts Contributes to Growth in the Creative Industries', Creative Industries Federation (2015)

When technology and the arts come together, there always seems to be a real spark of extra creativity. It's as if the two feed off each other to amplify an initial idea. Around the country, I've been introduced to some of the many arts and tech innovation hubs that are springing up.

In Nottingham, Broadway Cinema is home to Near Now, a producing, commissioning and artist development programme, which 'works closely with artists and designers to produce and present playful projects that explore technology in everyday life'. Artists use many of the disciplines that are more familiar to the technology world to develop new creative ideas, solutions and processes.

Meanwhile, Pervasive Media Studios based at the Watershed in Bristol hosts a community of artists, creative companies, technologists and academics exploring experience design and creative technology. Projects emanating from this collaboration between the University of the West of England and the University of Bristol include gaming, projections, music, connected objects, location-based media, robotics, digital displays and new forms of performance.

When I visited the Faculty of Creative and Cultural Industries at the University of Portsmouth, the students and researchers showed

When technology and the arts come together, there always seems to be a real spark of extra creativity.

me an Aladdin's cave of virtual reality technology, much of which could change the relationship with how we interact with arts and culture in the coming years. They've already begun thinking about just some of the creative possibilities this new high-end technology could introduce into our lives once prices for it fall and it becomes part of the mainstream.

However, my favourite use of new technology in a cultural setting came not in this country, but while I was on holiday in New York. I visited the Cooper Hewitt Design Museum, which is not far from those other great NYC cultural icons, the Guggenheim and the Metropolitan Museum of Art. The curators at Cooper Hewitt have made technology the central selling point of a visit to their newly renovated museum. When you buy your ticket, you are handed a digital pen, which enables you to interact with virtually everything on show. You can use it to draw on large touchscreen tables and to zoom in on pictures to find out more about objects from the collection that aren't on show in current exhibitions (everything has been digitised). Now, this is the bit that really excited me – you can 'collect' and 'save' objects around the gallery by simply pressing the pen onto any of the museum labels. All the details – as well as any art you create yourself while you're there – are saved to a dedicated web address, which is printed on your ticket. When you get home, you can log on to the website, and everything you have collected during your visit is there for you to keep. It's absolutely brilliant. I would love to see it in every museum the world over.

It's the sort of innovation that is loved by Ian Livingstone, the co-founder of the retailer Games Workshop and former chairman

of the British software technology developer and video game publisher Eidos. He believes that the bond between technology companies, artists and arts organisations is part of a continuous chain of creativity:

'We are only as good as our last creative idea. If we want to be a country of innovators we need to be constantly creative. To become creative, innovative and imaginative, we need to expose ourselves to new ideas. A vibrant arts and culture community is the easiest way to make this happen. The games industry has benefited enormously from increasingly sophisticated classical music soundtracks played brilliantly by orchestras like the Philharmonia. Many games developers now pay large sums to classical composers to write scores for their games, exposing a new generation of young people to classical music while enhancing the creative experience of playing these games. We have to stop thinking about arts and culture as simply nice to have. They are just as important as well-maintained roads and bridges. By giving us the chance to stimulate our minds with new ideas and experiences, they give us the opportunity to become more creative. Arts and culture are the infrastructure of the mind.' [5]

The Philharmonia Orchestra's meshing of classical music and new technology doesn't stop with the recording of symphonic video-game soundtracks. I caught up with their Universe of Sound project in a huge marquee pitched right outside Debenhams in the centre of Truro. This free interactive digital installation, which

[5] 'How Public Investment in Arts Contributes to Growth in the Creative Industries', Creative Industries Federation (2015)

has been touring around the south-west of England, allows anyone to explore an orchestra from the inside. The Philharmonia's players, under the baton of Principal Conductor Esa-Pekka Salonen, perform Holst's *The Planets* on screens all around you. As you walk through the different sections of the orchestra, you hear and see the piece of music from the point of view of a player in that section. The project uses planetarium-style projections, massive video screens, touch screens and movement-based interaction so that you can change what happens to the music and the orchestra in front of your eyes and ears. It's an illuminating introduction to how an orchestra works and, on the afternoon I was there, the marquee was packed full of people of all ages, all immersed in classical music.

The Royal Opera House is another cultural organisation that has embraced the use of new technology to take its art to audiences beyond those it can fit inside its Covent Garden home. Through a network of big screens, people around the country have been able to watch the highest-quality opera free of charge in city centres. Meanwhile, the introduction of screenings in theatres, halls and cinemas up and down the land has taken the art form to even more people. Other major arts organisations do the same, with the National Theatre's NT Live streaming to venues all over England, from the Stephen Joseph Theatre in Scarborough to the Courtyard

" *The bond between technology companies, artists and arts organisations is part of a continuous chain of creativity.* "

Theatre in Hereford, and from the Brewery Arts Centre in Kendal to St George's Theatre in Great Yarmouth. More than four million people have watched NT Live broadcasts since their inception in 2009. Research commissioned by Arts Council England and the British Film Institute shows that in 2014, this live event cinema was worth more than £35 million in the UK and Ireland and accounted for more than 3 per cent of total box office sales.[6]

Not only do these screenings increase homegrown audiences for these major national companies, but with cinemas and theatres around the world participating, these screenings boost the international 'brand recognition' of producing companies. The number of audiences seeing theatrical shows in this way is impressive. At the end of 2015, one live stream of Benedict Cumberbatch starring in a Sonia Friedman production of *Hamlet* at London's Barbican Centre was watched by more than 225,000 people in cinemas around the globe. At the same time, smaller players such as Cornwall-based Miracle Theatre are beginning to use the available technology to stream their productions to a far wider audience than would otherwise see them.

For the Royal Shakespeare Company, this type of live event cinema offers a huge boost:

> *'Extending reach through our Live from Stratford-upon-Avon cinema broadcasts and our free Schools' Broadcasts... has been*

[6] TBR Economic Research and Business Intelligence, 'Understanding the Impact of Event Cinema: An Evidence Review', Arts Council England and the British Film Institute (2015)

*game-changing in terms of our offer to young people and teachers
and for our international reach.*[7]

Traditional broadcasters also offer opportunities for taking publicly invested arts content and disseminating it to much wider audiences than would traditionally be achieved in a museum, gallery, opera house, concert hall or a theatre. Sky Arts, Channel Four and ITV all have a role to play, as do commercial radio stations such as Classic FM and Jazz FM, and digital content aggregators such as YouTube and Google; but I believe that the BBC offers the greatest opportunity in this regard.

The BBC is publicly funded, and has an obligation to provide a service to the public. Whether it is the broadcasting of existing cultural events, the creation of television-specific artistic events, documentaries and magazine programmes profiling arts and culture, or more general programming that blurs the line between entertainment and art, the BBC has a responsibility – and is best placed – to lead the way.

The director general of the BBC, Tony Hall, was formerly chief executive of the Royal Opera House, so it is not surprising that arts programming has featured large since his return to the corporation in 2013. There has been a marked increase in the prominence of the arts on BBC television and radio and on the iPlayer. It looks

7 Digital R&D Fund for the Arts, 'Digital Culture 2015: How Arts and Cultural Organisations in England Use Technology', Nesta, Arts & Humanities Research Council, Arts Council England (2015)

as if Hall regards this area as a personal legacy. He made this clear at the launch of a new BBC Arts strategy in 2014:

'We're the biggest arts broadcaster anywhere in the world – but our ambition is to be even better. I want BBC Arts – and BBC Music – to sit proudly alongside BBC News. The arts are for everyone – and, from now on, BBC Arts will be at the very heart of what we do. We'll be joining up arts on the BBC like never before – across television, radio and digital. And, we'll be working more closely with our country's great artists, performers and cultural institutions.' [8]

So how are cultural organisations doing digitally?

There's no doubt that some arts and culture organisations are embracing the opportunities that new technology offers them. There is, however, a question as to whether all arts organisations have the skills necessary to grow their expertise as fast as many private sector companies, and whether they possess the funds to invest in the R&D that is necessary for true innovation.

The National Endowment for Science, Technology and the Arts (Nesta), the Arts & Humanities Research Council and Arts Council England together created the Digital R&D Fund for the Arts, a £7 million pot of money that has supported collaboration between arts organisations, technology providers and researchers. In its annual publication of research into the area, released at the end of 2015, 984 arts and culture organisations were questioned

[8] http://www.bbc.co.uk/mediacentre/latestnews/2014/bbc-arts-release.html

about their relationship with digital technology. The results offer an interesting snapshot:

- *90% regard digital technology as important for marketing*

- *80% regard digital technology as important for preserving and archiving*

- *74% regard digital technology as important for operations*

- *54% regard digital technology as important for creation*

- *52% regard digital technology as important for distribution*

- *45% regard digital technology as important to their business models*

- *72% report a major positive impact from digital technology on their ability to deliver their mission* [9]

Some of the early signs from this survey are good, but it's a mixed picture. It's concerning and surprising that fewer than half of arts organisations see digital technology as important for their business models. This is a fast-moving world and arts and culture organisations can't afford to stand still. They need to be as creative in embracing technological advances as they are in what they might regard as the 'core' part of their business.

9 Digital R&D Fund for the Arts, 'Digital Culture 2015: How Arts and Cultural Organisations in England Use Technology', Nesta, Arts & Humanities Research Council, Arts Council England (2015)

Technology should not be seen as an add-on to what they do, but a central pillar of their creative strategy – and one of the ways in which they can distribute the art that they create to the widest possible audience. We all talk a good deal about reaching younger audiences, but without a coherent strategy for distributing content on handheld digital devices, there is a risk that arts content could become irrelevant to whole swathes of the younger generation, because this is how young people consume most of their entertainment. Given the abundance of creativity within the arts and culture sector, we should be at the vanguard of development in this area, rather than playing catch-up.

Cultural organisations need to use all of the data available to them to maximise business opportunities – and this includes sharing data between organisations. Failure to do this means that producers, programmers, marketers and venues are operating without the insights that might enable them to transform their businesses.

For those arts and culture organisations who are prioritising it, investment in technology is paying dividends by enabling them to take the best creative work to more diverse audiences in more efficient and effective ways. These are the clear benefits of the Innovation Dividend. But more than with any other area of investment, there is a risk that by investing too little too slowly, this

" Technology should not be seen as an add-on to what arts organisations do, but a central pillar of their creative strategy. "

dividend will quickly slip away. And because technology allows all arts and culture organisations, wherever they happen to be based around the globe, to compete as equals, the competitive challenges are as likely to come from the other side of the world as they are from just down the street. As US President Barack Obama noted in his very first State of the Union address:

> *'The first step in winning the future is encouraging American innovators. None of us can predict with certainty what the next big industry will be or where the new jobs will come from. Thirty years ago, we couldn't know that something called the Internet would lead to an economic revolution. What we can do – what America does better than anyone else – is spark the creativity and imagination of our people.'*[10]

The UK's creative industries are good at innovation, but our international competitors are good too, so we can't afford to rest on our laurels. The challenge is coming from countries such as China, India and South Korea, all of which are proving to be great innovators when it comes to the creative industries. We must continue to invest so that innovation can thrive in the UK. Only then will we be sure that the Innovation Dividend will continue to be realised.

[10] https://www.whitehouse.gov/the-press-office/2011/01/25/remarks-president-state
-union-address

the place-shaping dividend

in brief ...

Artists, arts organisations, museums and libraries have the power to regenerate, define and animate villages, towns and cities, including those places where there has historically been little arts infrastructure or activity. Some of this country's most notable regeneration programmes have culture at their heart. Investment in arts and culture should be made in all parts of the country, enabling centres of artistic excellence and creativity to thrive throughout England. The role of local authority investment in arts and culture remains of paramount importance. Increasingly, universities are major investors in arts and culture in their local areas, sometimes directly running arts organisations. They are a positive force for good in their local cultural ecology.

Post-industrial growth

My first visit to the National Glass Centre in Sunderland was on a bright spring day. The view towards the mouth of the River Wear and the North Sea beyond was spectacular, with the sunlight sparkling on the dancing waves. I love the rugged beauty in the post-industrial landscapes of our towns and cities, particularly across the Midlands and the north of England. I'm fascinated by the stories that these places have to tell – their buildings offer glimpses of the past, hinting at the reasons they grew as towns and cities, suggesting great wealth and a legacy of civic pride. Many rose on the back of pioneering industry – in Sunderland's case it was shipbuilding and coal-mining – but faced economic decline as their traditional industries faded.

Today there is a sense of resurgence – with art and culture at its heart. That process makes a place like Sunderland exciting. It speaks volumes for the creative possibilities of what can be achieved in towns and cities through investment in art and culture. This delivers our fifth dividend, which centres on place-shaping.

My second visit to the National Glass Centre came amid the gale force winds and heavy rain that lashed the north of England towards the end of 2015. This time, I didn't hang about outside, admiring the views. The winds were so strong that I saw two women literally blown off their feet.

Whatever the weather, the National Glass Centre is a fantastic combination of a museum and gallery – and a living, breathing hub for creativity and learning.

It celebrates Sunderland's long history of glassmaking, which dates back more than 1,300 years. The gallery is at the forefront of glass-making and ceramics. At the time of my first visit, it was filled with stunning contemporary pieces by such artists as Emma Woffenden, Richard William Wheater and Jeff Zimmer, and of course, such renowned Sunderland-based glass artists as Jim Maskrey and Jeffrey Sarminento.

Because the building is operated as part of the University of Sunderland, it is also home to 130 students studying glass and ceramics. They range from teenagers starting out on careers and studying at Foundation degree level, through to expert students working for their doctorates. In addition, thousands of schoolchildren take part in education events each year and crowds of adults and children turn up to the free daily glass-blowing demonstrations. I enjoyed having a go myself – and I have the resulting glass bauble sitting in my office to prove it.

It's strategically important for growth in our national productivity that we develop centres of creative excellence across the country, just like we have in Sunderland. Artists of all disciplines should be able to live and work in their communities, producing original work that will enrich our national culture, while at the same time changing the face of their locality.

The benefit that can be gained from a sustained focus on art and culture in a place was clearly seen following Liverpool's year as City of Culture in 2008. At the time of writing this book, already Coventry, Hereford, Paisley, Perth, Stoke-on-Trent and

Sunderland are lining up to bid to be UK City of Culture in 2021, while Bristol, Leeds and Milton Keynes have announced their bids to be European Capital of Culture in 2023. Gloucester and the Tees Valley have even thrown their hats into the ring to be UK City of Culture 2025, almost a decade ahead of the year in question.

These titles are far more than a branding exercise. The winning cities in these highly competitive processes need to convince the judges that they have an artistic programme and sustained investment in cultural infrastructure that makes them worthy of the title. In Liverpool's case, the investment in becoming European City of Culture proved to be the key to a catalytic change. The same is true even for the cities that don't end up winning. Leicester put forward a very credible bid to become UK City of Culture 2017, but was beaten by Hull. Nonetheless, the benefits of the thinking that went into that bid have been huge for Leicester, with cultural activities now central to the way in which it defines itself as a place. Local leaders such as the elected mayor, Sir Peter Soulsby, and the vice-chancellor of De Montfort University, Professor Dominic Shellard, have driven forward the city's cultural agenda on the back of the interest sparked by the City of Culture bid. The people who live there have seen a massive place-shaping dividend, not least from the discovery of Richard III's burial place under a car park in

" *It's strategically important for growth in our national productivity that we develop centres of creative excellence across the country.* **"**

the city, which has seen a surge of heritage-related activities across the city, many of them under the stewardship of the University of Leicester.

Geographically, the winning UK City of Culture for 2017, Hull (or Kingston-upon-Hull to give it its correct title), may be slightly more to the edge of England than Leicester, but it can claim its place at the centre of this country's history. I should declare an interest at this point, having spent three incredibly happy years studying politics at the University of Hull. It's a real, gritty city, a great port with a proud industrial legacy and a place that prizes self-sufficiency and individual thought – a home to whalers, fishermen, dockers, Quakers, painters, poets and musicians. It's unquestionably seen hard times over the years, but it has never lost its creative soul. Now, there's a new spirit in Hull, with private investment, led by £310 million from Siemens and Associated British Ports. And there's the title of City of Culture for 2017.

These good things don't happen by accident. Instead, they come about because of leadership and partnership. Hull City Council worked with partners from government, from the University of Hull and from industry to bring business to Hull, as well as with national investment organisations such as Arts Council England. Even in difficult times, Hull kept its faith in the arts, so the Arts Council – and other funders – kept faith in Hull. The sense of ambition in the city has built over time, extending the cultural ecology of the place, which in turn has supported more ambition. Hull has seen an upward spiral of growth, with art and culture at its heart.

For me, it's not only about what is achieved in 2017. It also has to be about a legacy of cultural growth. The year of being UK City of Culture will enable Hull's leaders to change the place in physical terms – there's significant capital being invested in rebuilding work. But, just as importantly, the stimulus of culture can show the people of Hull what more is possible with their city; it can change the perceptions they have of their environment. It has already changed the world's perceptions of Hull. At the beginning of 2016, Hull was named as one of the 'Top 10 Cities' in the world to visit, alongside Reykjavik, Nashville and Amsterdam, by the *Rough Guides* travel books:

> *'After being named the least romantic city in the UK in 2015, and once crowned one of the "crap towns" of the UK, things are finally looking up for Hull. It's the UK City of Culture in 2017, so this year is Hull's practice run. It'll be brimming with new hotels and restaurants, and even more of that distinctive home-grown creativity the city has always had. There are atmospheric old-timey pubs, eight excellent museums and a picturesque Old Town with cobbled streets. This year's fun is set to culminate in the September Freedom Festival, when the entire city is turned into a stage for performers and artists.'*[1]

That Hull has gone from being named the worst place to live in the UK in 2003 to being one of the world's essential destinations shows the journey the city has made. It also demonstrates the power that long-term strategic investment in arts and culture has to change a place for the better.

[1] http://www.roughguides.com/best-places/2016/top-10-cities/#ixzz3wrmWYkSM

While Hull is now starting to see the dividends of cultural invest-ment, civic leaders in Manchester have been exploring this phenomenon for the past two decades.

I was in Manchester in July 2015 for the premiere of *wonder.land*, a new musical by Damon Albarn and Moira Buffini, inspired by Lewis Carroll's *Alice in Wonderland*, and directed by the National Theatre's artistic boss, Rufus Norris. The production was part of the fifth Manchester International Festival and the streets around the Manchester Palace Theatre were thronging with people enjoying themselves. I knew I was in a city that took its culture seriously.

From the moment I got off the train at Piccadilly Station, I was aware of the Manchester International Festival; it was advertised behind the reception desk of the hotel as I checked in; there was a brochure sitting on the desk of my hotel bedroom; and virtu-ally every lamppost was hung with banners advertising artistic delights. In Manchester, you feel as though you are in a city that declares that the arts are for everyone – and follows through on its words.

The city has committed to long-term investment in culture build-ings – the infrastructure that sits behind the glittering events. The Bridgewater Hall has been the base for the excellent Hallé Orchestra for the past twenty years and the Royal Exchange is home to exciting and innovative theatre – but Manchester's ambition is bigger still. During 2015, the Whitworth Art Gallery reopened after a £15 million rebuild and was named 'Museum of

the Year'. Meanwhile, up the road, a brand new theatre, gallery and cinema complex called HOME opened to great acclaim. Plans are also shaping up for The Factory, a new flexible arts venue on the site of the old Granada Television studios in the city centre, previously the home of *Coronation Street* for five decades.

The scale of civic ambition is plain in Manchester's stunning Central Library, which has to rank as being among Europe's finest twenty-first century libraries – even though the building that houses it was actually built in the 1930s. It reopened in 2014 after a four-year renovation project.

Of course, the city has a long cultural and creative tradition exemplified by the generations of outstanding creative practitioners who have studied at the renowned Manchester School of Art and at the equally widely respected Manchester Writing School, both of which are central parts of Manchester Metropolitan University. With the Poet Laureate Carol Ann Duffy, a professor at the University, the vice-chancellor Professor Malcolm Press is seizing the opportunity to capitalise on his institution's international reputation in these areas.

The Leader of Manchester City Council, Sir Richard Leese, and Manchester City Council's chief executive, Sir Howard Bernstein,

❝ *In Manchester, you feel as though you are in a city that declares that the arts are for everyone – and follows through on its words.* ❞

share an unstinting commitment to investment in culture – and an informed understanding of the dividends that this will generate. They have been working side by side for the past two decades; Leese does not see investment in cultural infrastructure as being less important than other infrastructure investment:

'This reinvention – regeneration by another name – must look not just at the staples of business, economic, transport, education and community infrastructures, but also at cultural infrastructure. Ensuring a city has a "cultural offer" that makes it a place where people and businesses want to live, work and invest is not just desirable – we believe it is essential.'[2]

Bernstein is in no doubt as to the Place-Shaping Dividend that investment in culture has had on his city:

'We consciously see Manchester's thriving cultural scene as a key part of the city's distinctive appeal – for existing residents, visitors and investors alike. Not only can cultural attractions serve as anchors to attract complementary investment – as we have already seen with HOME in First Street and expect to see on the former ITV Granada site with The Factory Manchester – but the sort of creative people who flock to the city also have a valuable contribution to make.'[3]

[2] Leese, Richard, 'Budgets and finance are important for renewal. But don't forget culture.' *Guardian* (17 May 2015)

[3] Bernstein, Howard, 'Opinion', *Manchester Evening News* (1 February 2015)

A capital question

It was important to me that in my first major speech as chief executive of the Arts Council, in Hull in May 2015, I addressed the issue of the amount of investment in arts in arts and culture inside London, versus the amount invested outside the capital.

In recent years, the Arts Council has increased its investment of National Lottery revenue outside London up to 70 per cent (from a historic position of 60 per cent). But it intends to do better still and is committed to increasing this by at least a further 5 percentage points. By the end of 2018, a minimum of 75 per cent of the Arts Council's lottery revenue will be invested outside London.

The Arts Council is making this investment by targeted use of strategic funds, so that it does not harm investment in London's arts and culture sector. I'm wholly committed to maintaining London's status as a world capital of the arts. A flourishing London, with arts and cultural organisations that serve the whole nation, is essential. There is already a strong two-way flow of talent between London and the rest of the country; but that doesn't mean that this flow couldn't become more equitable and more free.

" *A flourishing London, with arts and cultural organisations that serve the whole nation, is essential.* **"**

As Claire McColgan, director of culture in Liverpool puts it, the country's creativity needs to be driven from more than one place:

'London is not a threat, but it's also not everything. There is a vibrant cultural offer from Northern Cities like Liverpool. The country can't survive on just the London cultural offer.' [4]

London's international reputation owes much to its arts and cultural life. That is recognised the world over and we should cherish it. If we're talking galleries, there's Tate Britain, Tate Modern, the National Gallery and the National Portrait Gallery; if it's museums you want, take your pick from the British Museum, the Victoria and Albert Museum, the Design Museum, the Natural History Museum, the Science Museum or the London Transport Museum; and then there's the National Theatre, Sadler's Wells, the Southbank Centre and the Barbican Centre; other cultural gems include the British Library, the Royal Albert Hall, the Globe and the Roundhouse; not to mention the thriving West End theatres. Walk along any central London street and it won't be long before an opportunity to engage with arts and culture presents itself.

For the former Mayor of London, Boris Johnson, a capital city without investment in culture is unthinkable:

'No one would ever want to live in a city without culture. Culture is the fuel that drives the urban metropolis. Artists, literary thinkers,

[4] 'UK Cities Report 2015', BOP Consulting (2015)

designers and directors feed our souls and our imaginations, offering both a mirror and a chance to escape.'[5]

When organisations such as Tate take their expertise, knowledge and cultural collections to other parts of the country, we see the benefits of a two-way flow between the capital and the rest of England. Tate Liverpool and Tate St Ives retain the central tenets of what it is to be a Tate gallery – curatorial excellence, presentational flair and artistic integrity – while the offering in each place is also infused with an authentic local flavour. The internationally recognised and respected values of the 'brand' that was honed by Sir Nicholas Serota and his team in London have successfully been transferred to completely different parts of the country.

The addition of the Plus Tate network of independent contemporary art galleries around the country means that thirty-five different places can benefit from Tate expertise and association with the Tate brand – though each gallery still operates as a completely separate organisation. It's a fine example of a London-based organisation taking on a national leadership role and improving the cultural lives of art lovers all over England.

Along with the National Galleries of Scotland, Tate also owns and manages the 'Artist Rooms' collection of contemporary art, which was acquired for the nation through a generous donation by the leading art dealer, collector and curator Anthony d'Offay.

5 'How Public Investment in Arts Contributes to Growth in the Creative Industries', Creative Industries Federation (2015)

The collection includes works by major contemporary artists – all of which are toured to museums and galleries across the country. During my travels around England over the past year, I've seen exhibitions of work by Robert Mapplethorpe at the Bowes Museum in County Durham, Gerhard Richter at Plymouth City Museum & Art Gallery, Dan Flavin at Tate St Ives, Robert Therrien at The Exchange in Penzance and Jeff Koons at Norwich Castle Museum & Art Gallery. The collection is a brilliant resource with each show offering visitors the chance to immerse themselves in the work of a single artist – something I found a real treat. Importantly, this great art is getting out to all parts of the country – rather than expecting people to come to the art, it's being taken to galleries near them.

Gown defining town

As mentioned at the beginning of this chapter, the National Glass Centre is run by the University of Sunderland. It's one of an increasing number of universities that have extended their local place-shaping roles to include investment in art and culture. Universities tend to be run by culturally aware individuals, so there is often a genuine understanding of art and culture at the top, with a passion for supporting high-quality cultural activities.

❝ Great art is getting out to all parts of the country – rather than expecting people to come to the art, it's being taken to galleries near them. ❞

An exciting cultural environment helps attract students – and the best academic staff.

In my journeys around the country, I have also heard university leaders say that investment in art and culture is one way in which they can enhance the lives of everyone in their communities – including those who are not directly connected to the university. It's also a way to attract locally based students, many of whom might not otherwise have considered that university was for them.

The chairman of the University of Sunderland, Internet and software entrepreneur Paul Callaghan, and the vice-chancellor Shirley Atkinson see their university as a driving force behind cultural regeneration in the city, and have worked with Sunderland City Council and Arts Council England to form the Sunderland Cultural Partnership, which recently published its Cultural Strategy. Callaghan believes his university has a catalytic role to play:

> *'Universities, particularly outside London, have an increasingly important place-shaping role as local authorities' remit and resources shrink. Sunderland, an industrial age powerhouse now redefining itself in the twenty-first century, has just such a university recognising not only the intrinsic value of culture but also the economic and social benefits that it brings to this transformation. Describing itself as "life changing", Sunderland University understands that lives change not only through our teaching and research but also through exposure to culture and so, by acting as a cultural leader, provider and catalyst, we help Sunderland become a better place for its citizens and our students.'*

The pattern is being repeated around the country, with the University of Derby taking over the running of Derby Theatre; Teesside University now operating the Middlesbrough Institute of Modern Art; Coventry University playing a major role in the city's Music Education Hub; and the University of the West of England now working in close partnership with Bristol's Arnolfini contemporary art gallery. Universities are becoming increasingly important cultural brokers in cities up and down the land.

It's not a new phenomenon; for a long time, many universities have been investing in their own arts infrastructure, serving both students and the wider public. In the past year I've visited just a few of them, including the Warwick Arts Centre, which sits in the midst of the University of Warwick's campus. The University of Nottingham's campus is home to Lakeside Arts, containing the Djanogly Recital Hall, Theatre and Art Gallery, as well as a museum. Southampton University has the Nuffield Theatre, the Turner Sims concert hall and the John Hansard Gallery. Further north, Lancaster University operates its own Nuffield Theatre, as well as Lancaster International Concert Series and the Peter Scott Gallery. Also in Lancashire, Edge Hill University's campus in Ormskirk includes the Rose Theatre and a separate studio theatre. Meanwhile, Plymouth University's Peninsula Arts occupies a city centre location, as does the University of Newcastle's Hatton Gallery, with the university campus also providing a home for Northern Stage.

I was at Norwich University of the Arts for the opening night of its brand new East Gallery. The vice-chancellor, Professor John Last,

told me that universities should have a 'social contract' with the places they inhabit – as exemplified by his new gallery:

> *'We're all about establishing a creative academic community in which staff and students can make work and research. We're inevitably part of our extended community, and for Norwich University of the Arts, our role in the city and the east of England helps create a dialogue between the university and external audiences. A key aspect of this for us was the establishment of our new, city centre gallery where contemporary work is shown both to public audiences and our university community. Whilst we get no extra funding for this, we see it as our "social contract" with our region and a vital element of the University's role as a place maker and shaper.'*

A specialist arts university like Norwich University of the Arts may have a specific impetus to engage culturally with the public. But this enthusiasm is not restricted to arts-orientated institutions. Liverpool John Moores University is home to 25,000 students. It's run by vice-chancellor Professor Nigel Weatherill, a mathematician who specialises in aeronautics. During his time in Liverpool, his university has built close links with the city's arts organisations such as the Royal Liverpool Philharmonic Orchestra, the Liverpool Everyman and Playhouse theatres, Liverpool Sound City, the Homotopia festival, the Royal Court Theatre, Tate Liverpool and

❝ For a long time, many universities have been investing in their own arts infrastructure, serving both students and the wider public. ❞

the Walker Art Gallery. Although a scientist, Professor Weatherill is passionate about the importance the arts should play in the lives of the students who study at his university:

> 'There is much discussion about the skills required from our graduates. We expect them, of course, to be numerate, literate and to have the so-called soft skills, but of great importance is how these skills are applied creatively. Creativity is the real differentiator. Whilst the products of creativity are all around us, how do we teach creativity, how do we nurture creativity within our schools and universities? Art and Culture are an articulation of creativity. Hence they must be available in all different forms, to everyone, if we are to have an educational system that not only benefits and enhances the lives of individuals, but produces the skills required to drive forward our economy.'

Arts in rural areas

I was in Cumbria just a week before the devastating floods at the end of 2015. Already the ground was sodden and it was raining heavily when I was there, but nobody had any idea how treacherous conditions were to become. The disaster of the flooding was all the worse because many towns and villages had only just got back on their feet after facing 'once-in-a-lifetime' water levels six years before.

One place that suffered badly in 2009 – and again in 2015 – was Cockermouth. This small picturesque market town in the west of Cumbria is home to fewer than 9,000 people and is notable as

the birthplace of the poet William Wordsworth. It's a deeply rural town, a long way from the big city lights of Newcastle, Manchester or London. But the people who live there deserve the dividends of great art and culture as much as city dwellers.

There are challenges in delivering arts to rural communities, often centred around economies of scale, accessibility and a lack of physical infrastructure. Moreover, while delivering art in rural areas may mean bringing in a touring product, it is also about understanding and developing the culture that is already local to these places. Big towns and cities don't have the monopoly on creativity.

Cockermouth is lucky to have the Kirkgate Centre, a hive of cultural activity at the top end of the town. Based in a former Victorian School, the Kirkgate Centre not only boasts a 160-seat theatre; it also hosts Arts Out West, West Cumbria's rural touring arts programme, which helps local people to stage arts events in village halls. With just a handful of paid staff, the centre's secret resource is its group of well over a hundred passionately committed volunteers. Between them, they handle everything from selling tickets to sorting out the engineering for the stage shows.

For a 160-seat theatre, the ambition is remarkable, with a rich programme of live shows, family events, special happenings for older people, film showings and a series of community activities that make use of the former school's two floors. The tiny bar and even tinier ticket booth make it an attractive little theatre and the love that local people have for the building and what it puts on is palpable. You sense it, as soon as you walk through the door.

Making the finances stack up in places like this will always be a challenge – and that's where public investment in the arts can really count, more so than it does in bigger places. This part of Cumbria isn't packed full of high net-worth individuals – many who live in rural communities like this have incomes much lower than the national average. Often they rely on seasonal work such as the tourist trade. The repeated challenges posed by the flooding only serve to make the job of the Kirkgate team even more difficult – and the results they have achieved even more remarkable. In a place like rural west Cumbria the role public investment plays in the arts ecology is central to ensuring that there is a meaningful high-quality cultural offer. Without it, Cockermouth wouldn't have an arts hub such as the Kirkgate Centre, which would be tragic for the local community. On this small, communal scale, the correlation between public investment in art and culture and the social dividends are seen and felt all the more keenly.

There are towns and cultural venues like this across the country. In the south-west alone, I could cite as examples Prema in Dursley, or Bridport Arts Centre, or the Pound Arts Centre in Corsham, or the Devon Guild of Craftsmen in Bovey Tracey or Cinderford Artspace – each of these arts organisations does a massive job for communities that live in small places.

" While delivering art in rural areas may mean bringing in a touring product, it is also about understanding and developing the culture that is already local to these places. "

Changing people and places

So what about places in the country where engagement in arts and culture is not so good? Why is that? Perhaps there's a lack of arts infrastructure or there are higher than average levels of people who find themselves in tough financial circumstances. The Arts Council has set about addressing this with the launch of the Creative People and Places programme, which focuses on parts of the country where involvement in the arts is significantly below the national average. The aim is to increase the likelihood of people participating in arts and culture – either by creating their own artistic and cultural activities or by attending cultural performances, venues or events.

Rather than a top-down approach, with a centralised view of the art that people in these areas ought to be engaging in, much of the curating of the art involved in these projects comes from the people who live in these places. It's something that the Warwick Commission on the Future of Cultural Value noted as being important:

> *'We should be encouraging communities to see themselves as co-commissioners of their cultural and arts experiences, working with cultural partners locally and nationally. The challenge for the arts, culture and heritage sectors is to bring people from communities together in ways that reflect their expressions of identity and creative aspiration in a manner that can have a lasting impact on that local society.'* [6]

[6] Warwick Commission on the Future of Cultural Value, 'Enriching Britain: Culture, Creativity and Growth', University of Warwick (2015)

Part of the success of the Creative People and Places programmes is that they are united by common aims, but each of the twenty-one projects is delivered in a way unique to the place in which it is located. It means that the connection between the place, the organisations delivering the project and the local people is richer and more meaningful.

One of the enduring memories of my first few months at the Arts Council dates back to a trip I made to see the work of Bait, the Creative People and Places project in south-east Northumberland. Bait is based in the small towns of Ashington, Bedlington and Newbiggin-by-the-Sea. These are places that many people across England might struggle to place on a map, located in an area that has faced huge economic challenges since the closure of the coal mines. Engagement in arts and culture has traditionally been low – not least because there has been precious little cultural activity for people to engage with, even had they wanted to do. Bait's work is inspired by the Ashington Group, largely made up of coal miners, with no formal artistic training, who painted in the 1930s and 1940s. They became particularly well known thanks to the play *The Pitmen Painters* by Lee Hall – the man who also wrote *Billy Elliott*. *The Pitmen Painters* premiered at Live Theatre in Newcastle before transferring to the National Theatre in London, going on a UK-wide tour and opening on Broadway.

The Ashington Group's collection of eighty paintings has a permanent home at Woodhorn Museum, a former mine near Ashington. It's a lovely museum and well worth the trip to see the paintings, which offer an authentic glimpse of life in the area

between the two world wars. While I was there, I enquired how Bait had got its name. In Northumberland, 'bait' is a snack or lunch, and the name reflects people taking time to make and share something together. The Ashington Group capture 'bait time' in a number of their paintings.

Some conversations stay with you long after you have them. This was the case for me when I visited the Escape Family Support Centre in Ashington, which offers support to substance abusers and their families in Northumberland. Over tea and cake, I chatted for an hour or so with a group of women there who had been working with an artist, provided by Bait, to create their own works of art to hang on the centre's walls. Many of them had never considered that art could possibly be part of their lives: 'We thought it wasn't for people like us,' they told me. But after weeks of building up their confidence and skills, many discovered talents deep inside themselves that they simply didn't know that they possessed. For some, in their sixties, it was the first time they had done anything remotely artistic since they were at school half a century before.

The pride that these women felt in their work shone through as they led me down the corridors, pointing to their paintings, and explaining to me the stories behind each of their works. Not all of these stories were happy – but they were told with such eloquence and passion that they have remained with me since. I asked these new artists what effect this burst of creativity had had on them. To a woman, they said it had given them a renewed sense of pride and purpose in their lives.

Art can do that for people in powerful ways that can be hard to quantify. But I came away from Ashington certain that the investment in arts and culture in this area was paying real dividends to real people's lives.

The story was the same when I went to Blackpool. Behind the bright lights and seaside fun, there are some tough stories of genuine financial hardship and deprivation. Another of the Arts Council's Creative People and Places programmes, this time called Left Coast, is beginning to make changes to the place through the use of spectacular art on a grand scale.

The 21st-century library

While I was in Blackpool, I visited the town's library and it very quickly gained a place in my heart. I love libraries and the role that they can have in changing people's lives. It might be because I write books, but it's also because libraries seem to me to have a sense of 'possibility' and 'discovery' about them. When you walk inside their doors, you never quite know what you might learn. They are places of transformation, both individually and communally. Libraries are institutions that have built up trust. They have an authenticity about them. And in a world where public space is

" *Libraries have a sense of 'possibility' and 'discovery' about them. They are places of transformation, both individually and communally.* "

rapidly being eroded, they represent a safe and egalitarian refuge and resource.

There is a huge public confidence in libraries, based on that legacy of trust, which means that these buildings can – and should – be at the heart of our communal life. It's important that libraries continue to be reinvented for the digital future. Libraries have long been ahead of the game in gathering data through library membership, adjusting to the needs of their public, and showing their value through that first point of contact. Think how many lives have been shaped by the advice of a librarian to try this book or that one. The recent roll-out of Wi-Fi throughout England's library network recognises the important role in social connectivity that these buildings play.

But I believe that this connectivity is only part of a bigger communal role, in which the physical space of libraries remains crucial – just as the physical nature of a book is unique. The digital era is here, with all its possibilities for virtual engagement. But it isn't a substitute – it's an addition.

The entrepreneur and philanthropist William Sieghart wrote an independent government report on libraries in 2014. He said:

'Libraries are... a golden thread throughout our lives. Despite the growth in digital technologies, there is still a clear need and demand within communities for modern, safe, non-judgemental, flexible spaces, where citizens of all ages can mine the knowledge

of the world for free, supported by the help and knowledge of the library workforce.' [7]

The chief executive of the British Library, Roly Keating, has made the point that while his organisation has been at the forefront of the digital evolution, libraries have a special something that may outlast the Internet. He has pointed out the time frame in which libraries exist – the digital world is barely a teenager while the library has been around for thousands of years. And what libraries represent, with that special legacy of trust and authenticity, is strong enough to accommodate change and still endure.

Libraries are democratic spaces where knowledge is there to be explored. You can either choose where to go to find something specific, or you can let serendipity lead the way. Libraries allow for social mobility; they are places of possibility, opening doors in later life for many people for whom school didn't work. The librarian is there to make sense of the information overload, to be a font of wisdom, advice and guidance. This was neatly summed up by the author Neil Gaiman when he said:

'Google can bring you back 100,000 answers. A librarian can bring you back the right one.'

Originally, Blackpool's library was endowed by the Scottish-American businessman Andrew Carnegie. His philanthropic giving

[7] Sieghart, William, 'Independent Library Report for England', Department for Culture, Media and Sport, and Department for Communities and Local Government (2014)

resulted in more than 2,500 libraries being built around the world, with some 660 in the UK. Blackpool's central library must be one of the most attractive in the country. And Blackpool Borough Council has continued to invest in the building. Inside, it's bright, colourful and welcoming. On the day I was in town, it was full of people reading books and newspapers, using the free computer terminals, or in the friendly café grabbing a break from the hubbub of the busy streets outside.

When I walked in, I noticed that individual words were etched on the windows around the central ground-floor area. It turned out that each word was chosen by the people of Blackpool to define what the library meant to them:

> *Belong*
>
> *Illuminate*
>
> *Aspire*
>
> *Freedom*
>
> *Reflect*
>
> *Stories*
>
> *Imagine*
>
> *Curiosity*

I believe they're a wonderful set of words that show how a cultural building can play such an important part in a place – and in the

lives of its people. Each of these words is in itself a dividend that comes about directly from a library's place-shaping role.

I've visited some terrific libraries over the past year, including the newly refurbished central libraries in Manchester and Liverpool, both of which are shining beacons of excellence. The Hive in Worcester, which is a partnership between Worcestershire County Council and the University of Worcester, offers a blueprint of how a local library and an academic library can come together to make a truly inspiring place, as does The Forum in Southend, which is a partnership between Southend-on-Sea Borough Council, the University of Essex and South Essex College. And then there are brand new libraries where I donned my hard hat and high-vis jacket to clamber around during their construction, including Storyhouse in Chester, The Curve in Slough and The Word in South Shields – all three of which will be huge cultural assets to their local areas. Meanwhile, I saw exciting new plans for a brand new library in the centre of Barnsley while I was in the town, and I visited a new local library in Nottingham on the day that it opened for business in an NHS centre right next door to the doctors' surgeries. So, although there are challenges to the funding of libraries, there are still innovative investment projects happening up and down the country.

** *Libraries allow for social mobility; they are places of possibility, opening doors in later life for many people for whom school didn't work.* **

Artists change a place

Of course, it's not just buildings and cultural institutions that can change a place for the better – it's people too. And, in particular, it's artists. I've seen this time and time again. I noticed it at Islington Mill in Salford. Since the turn of the millennium, a group of artists has lived and worked together in this converted red-brick Victorian mill with its attractive cobbled central courtyard.

Over another delicious home-cooked supper, they told me about their creative space, which centres on collaboration between visual artists making work, galleries where that work is exhibited, recording studios, an events space, and even a bed and breakfast, where artists can stay overnight. Some 15,000 people visit every year and around 100 artists are attached to the building in one way or another. Every inch of the place radiates creativity, with almost every spare surface being used to make, store or exhibit fascinating new pieces of art.

At the other end of the country, I encountered the same buzz at the Resort Studios in Margate. Located in the Pettman Building, a historic Victorian warehouse in Cliftonville, the founders – themselves a group of artists – have created a home for other creatives, including designers, architects, photographers and curators. There's also a printmaking studio, a photographic darkroom and a jewellery workshop.

Resort Studios is just one of a burgeoning number of artist collectives that have made Margate their home. It's no accident that the

town's popularity as a creative hub has increased dramatically since the opening of the Turner Contemporary, an imposing art gallery right on Margate seafront, next to the town's harbour. The Turner Contemporary came about as a result of a creative vision for the town, which was heavily supported and driven forward by Kent County Council, Thanet District Council, Arts Council England and other public funders and regeneration agencies.

Since it opened in 2011, Turner Contemporary has proved to be a magnet for artists, with galleries and workshops popping up in unloved and disused buildings all around the town. These artists are literally brightening up Margate, with splashes of colour and creativity in unexpected places. Together they're changing the place where they live and work for the benefit of the community as a whole. In just a few short years, their presence is already paying dividends for Margate, lending the place a new sense of optimism and excitement. In the words of Turner Contemporary's founding chairman, John Kampfner:

> *'A cycle of decline can be reversed. A single building is never going to achieve regeneration on its own. It sows the seeds, requiring local decision-makers to exploit the opportunities presented. At times of hardship, it requires more such examples, not fewer. The greatest poverty of all is poverty of aspiration.'* [8]

[8] Kampfner, John, 'Margate proves investing in our culture makes economic sense', *Independent* (25 April 2011)

the enterprise dividend

in brief ...

Investment in arts and culture pays out economic benefits, including creating jobs and driving commercial success in related industries. Cultural tourism reaps financial rewards for villages, towns and cities. Arts and cultural organisations need to develop a spirit of enterprise and entrepreneurialism to enable them to thrive. New financial models have the potential to unlock greater creativity in cultural businesses. Our creative industries are renowned on the international stage and this pre-eminence relies on continued investment to enable the UK to carry on innovating and exploiting its intellectual property to its full potential.

The enterprise ecosystem

The Arts Council Collection has been commissioning and acquir-
ing excellent art for more than seventy years – a lot of which is
on tour in galleries up and down the country at any given time.
One of my favourite pieces is a drawing by Jeremy Deller called
The History of the World, 1997. It shows the social, political and
musical links between acid house and brass bands, drawn as a
flow diagram.

On the face of it, acid house and brass bands may well seem to
be two very different worlds, but Deller uncovers a surprisingly
large number of geographical, historical and social connections.
The same is true with the worlds of public and private investment
in art and culture; they are linked in a funding ecology made up
of four principal sources of revenue: commercial, philanthropic,
local authorities and national public funding.

Commercial revenues are in the main formed of ticket sales, paid-
for events, business sponsorship and the retailing of food, drink
and other merchandise. Philanthropic revenues rely on smaller
charitable donations from groups of patrons or from larger pay-
ments made by high net-worth individuals. Local authorities still
make up the bulk of funding of arts organisations, museums and
libraries, with other public investment coming from bodies such
as the Arts Council, which distributes 'grant-in-aid' funding from
the government and also 'good causes' revenue from the sale of
National Lottery tickets.

Some cultural organisations have public investment as a significant part of their revenue streams; others operate with it as only a small part of their income; and a third group operate on a completely commercial basis with no public money. Having said that, even this third group tends to be linked to organisations from the first and second group, with a flow of talent, ideas, products and investment running throughout. The Warwick Commission on the Future of Cultural Value noted that none of these funding streams operates in isolation:

'It is important to stress the interdependence of the economically successful parts of the creative industries with these publicly supported sub-sectors.'[1]

This idea is backed up by research published in 2015 into the relationship between public investment in theatre and the commercial end of the theatre world. It shows that public funding plays an essential part in the whole theatre industry, supporting a national infrastructure and private sector activity valued at £2.27 billion.[2]

It would be easy to categorise the returns of this investment in purely economic terms. And, indeed, there *are* great economic returns to be enjoyed from sustained investment in arts and culture – and we should never shy away from underlining that fact.

[1] Warwick Commission on the Future of Cultural Value, 'Enriching Britain: Culture, Creativity and Growth', University of Warwick (2015)

[2] Hetherington, Stephen, 'The Interdependence of Public and Private Finance in British Theatre', Arts Council England, Birmingham Hippodrome, Theatre Development Trust (2015)

The Local Government Association identifies five key ways that arts and culture can boost local economies:

- *attracting visitors*

- *creating jobs and developing skills*

- *attracting and retaining businesses*

- *revitalising places*

- *developing talent*[3]

However, to *only* measure this particular set of benefits in economic terms would be to underestimate many of the wider financially related social benefits that arts and culture can bestow on a place and its people. It's as much a state of mind and a way of operating as it is a set of numbers on a balance sheet. So, rather than this chapter being entitled 'The Economic Dividend', it's instead called 'The Enterprise Dividend'.

Public investment driving commercial success

Let's begin with some numbers. The UK's creative industries grew by 8.9 per cent in 2014. That's almost double the UK economy as a whole, with the sector now worth £84.1 billion to our country's coffers.[4] On top of that 2,343,000 people are employed

[3] 'Driving Growth Through Local Government Investment in the Arts', Local Government Association (2013)

[4] https://www.gov.uk/government/news/creative-industries-worth-almost-10-million -an-hour-to-economy

in the creative industries in the UK – that's 7.91 per cent of all employment.[5]

These are big numbers and it's no wonder that other countries around the globe are sitting up and taking notice of the UK's success in this field, analysing what we have done to spur on this growth. To maintain our position as a world leader we must continue to invest so that we can stimulate further innovation, development and growth – not least by building the education infrastructure that will ensure the emergence of the next generation of creative thinkers and makers who can drive forward our productivity in the coming decades.

In 2012, the European Commission highlighted for the first time the spill-over effects of the arts and culture and the creative industries – the side-benefits that come as a result of investment in art and culture. Research by Arts Council England and partner organisations from around Europe identified three areas where evidence of these spill-over benefits is particularly strong. These were **knowledge** (stimulating creativity and learning), **industry** (improving business and investment), and **network** (including urban development, health and wellbeing).[6]

[5] Nathan, Max; Pratt, Andy and Rincon-Aznar, Ana, 'Creative Economy Employment in the EU and the UK: A Comparative Analysis', Nesta (2015)

[6] Tom Fleming Creative Consultancy, 'Cultural and Creative Spillovers in Europe: Report on a Preliminary Evidence Review', Arts Council England, Arts Council of Ireland, Creative England, European Centre for Creative Economy, European Cultural Foundation, European Creative Business Network (2015)

One sign of the increased importance of this sector was the found-ing in 2015 of the Creative Industries Federation, a new national membership organisation for the public arts, cultural education and creative industries. Its chief executive, John Kampfner, makes it clear that the UK's success in this sector will crumble if we fail to invest in the next generation of talent:

'Culture is Britain's superpower. Wherever you go in the world, you hear plaudits for our TV and film, our fashion and design, not to speak of our amazing museums, galleries and theatres. Our companies are doing better than ever, and our creative industries have long outstripped the rest of the economy. It hasn't happened by chance. For two decades, sustained public investment and strong education and training have produced a golden generation of talent. By de-prioritising creative education and by challenging the value of investment in our arts, we are in danger of undermining that very pre-eminence – just when other countries are learning the secrets of our success.'

" To maintain our position as a world leader we must continue to invest so that we can stimulate further innovation, development and growth – not least by building the education infrastructure that will ensure the emergence of the next generation of creative thinkers and makers who can drive forward our productivity in the coming decades. "

Josh Berger, the president and managing director of Warner Bros. Entertainment UK and chair of the British Film Institute shares the belief that public investment in art and culture pays dividends for the more commercial end of the creative industries:

'As we continue to produce more films, TV series, video games and stage shows here in the UK, Warner Bros. hires the very best talent the country has to offer. To support this diverse pool of exceptional talent, and to ensure the UK maintains its position as a global leader of creative industries, we welcome and encourage both public and private investment in UK artists across the board.' [7]

Job creation is only one of the Enterprise Dividends from investment in art and culture – but a vitally important one for the economic health of a village, town or city. The Local Government Association commented on what it termed the 'pulling power' of art and culture. This is where the financial transaction of a visitor to a cultural institution is amplified by their wider injection of cash into the local area. Our visitors not only spend money on tickets, but also buy products or services from other local businesses – including restaurants, shops and hotels. On top of that, the cultural organisations themselves are direct investors in their local communities, buying services and supplies from local firms, with employees also spending their earnings in the vicinity. [8]

[7] 'How Public Investment in Arts Contributes to Growth in the Creative Industries', Creative Industries Federation (2015)

[8] 'Driving Growth Through Local Government Investment in the Arts', Local Government Association (2013)

This was brought home to me when I visited Theatre by the Lake, beautifully situated near Derwentwater on the edge of Keswick in the Lake District. With forty-five employees, this lovely theatre is actually the biggest employer in the area, so its importance is all the greater, not just because it offers local people and visitors alike the chance to experience high-quality live drama on a main stage and in a studio theatre in a pretty remote part of England, but because it provides a materially important financial boost for the local community.

On a much bigger scale, a report into the impact of Liverpool's year as European Capital of Culture in 2008 showed that there were 9.7 million visits to the city because of the arts programme put on that year. The additional economic value of these visits totalled £753.8 million. By the end of 2008, research suggests that 68 per cent of UK businesses believed that being European Capital of Culture had made a positive impact on Liverpool's image.[9] The Mayor of Liverpool, Joe Anderson, describes culture in the city as being the 'rocket fuel for its continued regeneration'.[10]

Further along the M62, Manchester City Council Leader Sir Richard Leese is adamant about the importance of linking arts and culture investment to growth in his city – both in economic terms and because it benefits enterprise there:

[9] Cox, T.; Garcia, B. and Melville, R., 'Creating an Impact: Liverpool's Experience as European Capital of Culture', European Capital of Culture Research Programme (2010)

[10] 'Liverpool Cultural Action Plan', Liverpool City Council (2014)

*'This clustering of cultural landmarks and events is not, of course, a
coincidence. Nor is it simply a celebration of the creativity that runs
through the history of the city. It's a direct acknowledgment of the
catalyst that culture can be for economic growth, as well as firing
imaginations and creative skills.'*[11]

The story is the same in Birmingham, with Anita Bhalla, chair of
its Creative City Partnership, drawing a link between the Learning
Dividend outlined in Chapter 2 and the payback in economic
terms years later:

*'The city's multicultural character and access to universities and
other educational establishments provide creative employers with a
steady flow of talent and our diverse and vibrant cultural scene helps
us to attract and retain this talent.'*[12]

Meanwhile, in London, just days after being elected as Mayor,
Sadiq Khan underlined the Enterprise Dividend paid back to the
capital from its investment in culture:

*'Supporting the arts and creative industries will be a core priority for
my administration – right up there with housing, the environment
and security – as one of the big themes that I want to define my time
as Mayor. There is no question London without culture would be a
much poorer place.'*[13]

[11] Leese, Richard, 'Budgets and finance are important for renewal. But don't forget culture.' *Guardian* (17 May 2015)

[12] 'How Public Investment in Arts Contributes to Growth in the Creative Industries', Creative Industries Federation (2015)

[13] Razaq, Rashid, 'Sadiq Khan: I'll take the arts as seriously as housing and crime', *Evening Standard* (19 May 2016)

The possibilities of cultural tourism are becoming more widely understood around the country – and the dividends are not only for the benefit of our biggest cities. Cornwall, for example, is not only attracting visitors because of its many beautiful beaches; it has a rich cultural and artistic heritage that is now being marketed extensively both to visitors and to permanent residents. Further east along the English coast, Brighton has built a reputation as an artistic and cultural hub with much of its economic growth now related to the creative industries. And the cultural heritage of Lincolnshire is now being presented to potential visitors in a coherent way that links together the area's rich offerings. All of these places use the high-quality artists, museums, galleries and libraries in their locality as part of the tourism offer available to visitors.

The impetus for increased cultural tourism can come from sometimes unexpected sources. *The Great Pottery Throwdown* television series on BBC2, which sees amateur potters competing against each other in the style of that runaway BBC hit *The Great British Bake Off*, has prompted a surge of interest in pottery across the country, with many classes now operating waiting lists. Sales of clay have also increased, as the viewing public try their hand at making pots at home. It's also done much to bring the traditional craft skills of Staffordshire potters back into the public eye.

❝ The possibilities of cultural tourism are becoming more widely understood around the country – and the dividends are not only for the benefit of our biggest cities. ❞

Paul Williams, head of the Staffordshire University Business School, says that the BBC's decision to base the series in Stoke-on-Trent has had a beneficial effect on the local area:

> 'That the arts and culture play an important and transformative role in building destination competitiveness and in underpinning the high-yield cultural tourism sector is now well established. As well as being a significant contributor to Stoke-on-Trent's economy, cultural tourism with a particular focus around the city's myriad ceramics attractions and pottery making is now reaching out to a much wider audience. This recent upsurge in pottery tourism has been partly fuelled by the success of BBC2's Great Pottery Throw Down, which took the medium of crafts and creative clay making into the viewing public's front rooms. The subsequent 'Throw Down' effect has boosted the number of purposeful and serendipitous cultural visitors to what some might regard as an unconventional tourist destination.'

I witnessed this myself when I was in Stoke-on-Trent to give a speech at the opening of the British Ceramics Biennial, which brought the city's sadly disused Spode factory back to life. This festival showcases the work of the very best ceramic artists from Stoke-on-Trent and around the world. That the British Ceramics Biennial happens here gives it added authenticity and integrity, building on the city's great heritage in ceramics. I sensed a real creative buzz about the place – and although the pottery industry has faced many challenges over the years, Stoke is still a hot-bed of ceramic talent, with Emma Bridgewater one of the biggest employers of potters in the area. With strong leadership from Stoke-on-Trent City Council and Staffordshire University, the

city's cultural infrastructure is gradually being reinvigorated thanks to groups of enterprising artists, like those I met at the AirSpace Gallery and B Arts. They're growing new cultural businesses in many of the disused industrial buildings in the city, with B Arts even opening an artisan bakery as part of the business model that funds its work in the arts. The sense of ambition in Stoke-on-Trent is clear to see from the commitment of Staffordshire University Vice-Chancellor Professor Liz Barnes to building a brand new multi-million pound National Centre for Ceramic Education and Research in the city. As well as researching new technologies, it will train the next generation of skilled workers in the area.

New ways of investing

Sometimes, the enterprise dividends from investment in art and culture don't come from making investment in traditional ways. We can sometimes see spectacular results where public or private money is used to help an arts organisation become more resilient and sustainable, rather than simply to fund its core product.

In 2009, a grant of £260,000 was given by the Arts Council to Live Theatre in Newcastle. Instead of directly funding the creation of a new play, this money was specifically intended to enable Live Theatre to invest in an adjoining gastro pub, The Broad Chere. That investment now delivers around £100,000 revenue per year back to Live Theatre, enabling it to use this money to fund its core artistic work. And from personal experience, I can testify that the food and drink is excellent. A delicious main course of black pudding, smoked haddock and mustard tastes all the better when you

know you're helping to fund a critically acclaimed production on the Live Theatre stage next door.

Also in 2009, the Arts Council made a £251,000 investment in Yorkshire Sculpture Park to fund a new car park. In the 2013/14 financial year, this upgrade to the site's infrastructure delivered a return of £500,000 to the attraction's coffers, allowing it to enhance its core artistic business.

There are many financial models for investing in art and culture besides simply making grants of public cash. But, to make myself absolutely clear, I am advocating these models as a means of growing the size of investment in art and culture, not to replace existing public funding. As I stated at the start of this book, I believe passionately that the funding ecology for art and culture in this country needs to have public investment at its heart. The lever of public investment ensures that we have an art and culture sector that is innovative and risk-taking – and that is reflective of all communities in society, reaching out to everyone everywhere.

That said, it would be wrong to ignore the possibilities of what can be achieved by private money. Philanthropic trusts and foundations such as the Paul Hamlyn Foundation, the Esmée Fairbairn Foundation, the Baring Foundation and the Calouste Gulbenkian Foundation have many decades' experience of careful, considered and insightful investment in arts and culture. And high net-worth individuals also have an important role to play: the Duke of Devonshire, who places art and culture at the centre of his Chatsworth estate in Derbyshire; the philanthropists Jonathan

and Jane Ruffer, who have put Bishop Auckland on the map as an internationally important centre for Spanish art and regenerated the town beyond all recognition; and the businessman Roger de Haan, whose sustained investment in cultural businesses has transformed Folkestone into a hub for creative people. We will always need visionary, far-sighted and generous individuals who have a love of the arts and culture, and pockets deep enough to enable real change.

In fact, we should do far more to encourage and cherish these people, who don't always receive the public praise that their generous philanthropy merits. While I do not advocate the American model of arts funding, which sees relatively little public investment and a huge reliance on private donors, the development of philanthropic giving to arts and culture organisations should remain a focus for arts organisations in this country, as part of our mixed funding ecology. It's something that the Arts Council has been developing through its Catalyst funds, which aim to help arts and culture organisations increase their fundraising capacity.

Other ways of investing are also starting to bear fruit. The Arts Impact Fund – a new partnership between Bank of America Merrill Lynch, the Esmée Fairbairn Foundation, Nesta and Arts

❝ *We will always need visionary, far-sighted and generous individuals who have a love of the arts and culture, and pockets deep enough to enable real change.* **❞**

Council England, offers repayable loans of between £150,000 and £600,000 to cultural organisations. With up to £7 million to invest, we could see some real innovation here because the fund offers an alternative to commercial loans and grant funding. It is the first of its kind in the world to look at the social, artistic and financial return from arts organisations. The first investments from the fund, announced at the beginning of 2016, include a £150,000 loan to Titchfield Festival Theatre in Hampshire, to help pay for the construction of a new building, which will enable this volunteer-run theatre company to tap into in new revenue opportunities and become more self-sustaining. Rather than a standard grant, this is an investment that will be repaid to the Arts Impact Fund over time, out of that additional revenue. It's also an example of one of the ways that the Arts Council is investing in the voluntary arts sector, which is an important part of England's overall arts and culture ecology.

New technology means that there will be new ways for everyone to become involved in arts philanthropy – the surface has barely been scratched. For example, think of what might be achieved through online crowdfunding of cultural activities. One way in which this has already been shown to work is for artists to invite the public to fund, say, 50 per cent of a project's value, with the local authority contributing the other 50 per cent once that target amount has been reached. This is yet another reason for arts and culture organisations to gather and share high-quality data on their audiences, because this will lead to more meaningful relationships with audiences and allow such fundraising mechanisms to operate in the most effective way.

There's nothing to suggest that we shouldn't explore other investment models in the future. Perhaps public funders and private enterprises could come together in a far bigger way to offer capital investment that would be repaid, or to act as guarantors to enable greater levels of structured financial risk by creative producers. If cultural enterprises become profitable, maybe they should pay a financial dividend back to their public funder for reinvestment in other nascent artistic enterprises. I'm not in any way advocating turning our backs on the more traditional grant model – but we should keep an open mind about such opportunities. All of these options are worth consideration at different times, and for different organisations.

The Chancellor of the Exchequer, George Osborne, has already done his bit to think creatively when it comes to taxation. The introduction of tax credits from the treasury to orchestras, theatres, and opera and dance companies, as well as new proposals to do the same for exhibitions, means that the arts and culture sector has benefited to the tune of many millions of pounds.

There is still much to do to ensure that our creative industries can continue to thrive on the international stage. In evidence given to the Culture, Media and Sport Select Committee in 2012, Martin Smith of the investment firm Ingenious Media identified the lack of scale of many of our creative companies as being a major threat to their global growth potential.[14] This means that they

14 http://www.publications.parliament.uk/pa/cm201314/cmselect/cmcumeds/674/674we15.htm

are vulnerable to takeover by bigger international players and are often poor at maximising the value of the intellectual property that they create. The risks are as potent a threat for a theatre company or visual artist in receipt of public investment as they are for a special effects company working in the commercial end of the film industry:

'In content production specifically, the UK's creative economy mainly comprises an eco-system of interlocking micro-businesses, freelancers and the self-employed. More than 90% of the UK's creative businesses employ four people or less according to the government's own statistics. Some of these companies are small because their founder-managers like it that way, but others are small because their owners do not know how to scale them up to grow and become commercially sustainable...

There will always be a large number of micro-businesses in the sector. From a purely creative point of view, small is both beautiful and productive. Creative talent flourishes best in relatively small and highly flexible units. However creative excellence does not guarantee commercial success. In a competitive global market small, weak, project-based business units are vulnerable to the effects of under-capitalisation, loss of clients, adverse currency fluctuations and the withdrawal of inward investment...

The biggest challenge is to find ways of helping significant numbers of these very small businesses to "scale up" (in investment-speak). We need to develop a solid core of sustainable content-creating businesses at the heart of our economy if we are to be commercially competitive

on a global basis. This means taking a much longer term investment horizon than is customary.[15]

The Enterprise Dividend can only be maximised when arts and culture organisations adopt enterprising behaviours. External funders and investors can come up with no end of innovative ways of channelling money into cultural organisations, but it's what these organisations do with the funding when they receive it that makes the key difference. Many artists and leaders of cultural organisations are highly enterprising; but others still have a long way to go. The Clore Leadership Programme, which has been running annually since 2004, aims to tackle this issue by educating emerging leaders from the cultural sector. Those who have been on the course – which is funded by Arts Council England and the Clore Duffield Foundation – now hold a range of influential leadership positions across arts and culture organisations. They are undoubtedly making a difference.

In terms of best practice, there's a lot that publicly funded arts and cultural organisations can learn from the more commercial end of the museums sector. Many members of the Association of Independent Museums operate their core cultural businesses with relatively little public investment, under the association's 'Prospering Museums' framework. I've visited three such venues myself: The Black Country Living Museum in Dudley; the SS *Great Britain* in Bristol; and the Compton Verney art gallery

[15] http://www.publications.parliament.uk/pa/cm201314/cmselect/cmcumeds/674/674we15.htm

in Warwickshire. The framework encourages museums to understand and articulate their purpose; to be financially resilient with strong governance; to steward their collections wisely; to focus on the needs of their visitors; and to be prepared to take innovation and risks. These are all good maxims by which any enterprising cultural organisation should be happy to live.

In 2013, Plymouth was named a Social Enterprise City, one of the first in the UK – and the marriage of cultural entrepreneurship with social enterprise has been a feature of the city's transformation. It can be seen through the work of the Real Ideas Organisation, which has knitted together social enterprise with culture and heritage to drive the transformation of the Devonport area – restoring the Devonport Guildhall as a cultural hub and the adjacent column as a civic beacon and visitor attraction. Its next project will involve a partnership with Plymouth University to restore Devonport's disused Market Hall as a digital innovation hub for children and young people.

Elsewhere in Plymouth, the arts producer and social enterprise company Effervescent, which specialises in work with young people, has forged a partnership with the children's charity

" Public funders and private enterprises could come together in a far bigger way to offer capital investment that would be repaid, or to act as guarantors to enable greater levels of structured financial risk by creative producers. "

Barnardo's and Plymouth University to secure commissions from the council in support of projects that empower children in care. These solutions are considered cost-effective and high-impact in relation to the alternatives. They're also seen as good exemplars of incentivising social enterprise in order to achieve the local authority's corporate outcomes.

The Enterprise Dividend is one of the most exciting outcomes of investment in art and culture. When we get it right it enables us to be more creative, to take greater artistic risks and to be truly innovative. Adopting new models from the business world; engaging with new methods of investing; and operating in an entrepreneurial way are all means for enhancing the creative and artistic possibilities for individuals, in organisations or in entire towns or cities. As I have maintained throughout this book, economic outcomes are by no means the only reason for investing in art and culture, but they are one important measure that can unlock new funding streams, allowing our artists and cultural organisations a greater opportunity to prosper. And we should never be ashamed of that.

the reputation dividend

in brief ...

A boost in reputation comes about as a result of all six of the previous dividends, but it is also a dividend in itself. Many of those towns and cities that enjoy creative and economic success can point to the presence of cultural infrastructure and artistic output as a significant part of their success story. These places have also developed a narrative that shows the importance of art and culture in building their reputation. Often, alliances of arts and cultural organisations are formed to help nurture that reputation. Positive reputations are hard won and easily lost, so continued investment is required if the benefits of this dividend are to be maintained over a long period of time.

Telling the story

The first of our seven Arts Dividends centered on creativity. It is the thread that runs through all six of the others. If we think of creativity as being a major input into each of these separate dividends, then our final dividend, which centres around reputation, is very much the 'output' of the process. When added together, all six of our other dividends have a cumulative effect on the reputation of an individual artist, a museum, a library, an arts organisation, a village, town or city – or even an entire art form.

It can take years of insight, consistency, productivity, creativity, vision, knowledge, practice and timing to build up a positive reputation. The old maxim that success breeds success holds true in the art and culture ecology just as much as it does in the worlds of business or sport. Building a credible and authentic narrative is central to successfully reaping the benefits of the Reputation Dividend.

The development of a strong reputation centres around what you do, what you say, and what other people say about you. For me, the most powerful reputation builder comes when the third of these is in full swing. When your story is being repeated by people unconnected to your narrative, that's when you know that your reputation is being enhanced.

Right now, by popular consensus, Manchester is leading in the reputation stakes as the place in the UK where interesting, exciting, innovative things are happening. As I've described in earlier

chapters, sustained investment in the city's cultural infrastructure and in its artistic output has built a compelling narrative that has driven forward the city's growing reputation as a beacon for arts and culture. This success isn't lost on Manchester City Council leader Sir Richard Leese:

> *"The importance of culture and the arts to Manchester's growing reputation cannot be overstated. Cultural regeneration is as much a part of the city's future as the many groundbreaking developments including graphene (famously isolated by researchers Andre Geim and Kostya Novoselov at Manchester University) and the like that are at the same time reshaping and advancing the city's global standing within the knowledge and skills economy."*[1]

This understanding of the way in which investment in arts and culture drives reputation is by no means limited to Manchester. When I met Karime Hassan, the chief executive and growth director of Exeter City Council, he made very clear to me the importance to the city of the Royal Albert Memorial Museum and Art Gallery (known as RAMM and home to the legendary Gerald the Giraffe). Far from seeing his local civic museum as a dusty repository for crumbling artefacts, he told me that it was always his first stop when giving a tour to representatives of multinational corporations considering locating in the city. Sustained investment has resulted in one of the most impressive, well-curated and inviting museums that I have encountered. Many of its collections are not

[1] Leese, Richard, 'Budgets and finance are important for renewal. But don't forget culture.', *Guardian* (17 May 2015)

only of national and international importance, they also showcase Exeter and south-west England in an exciting and dynamic way. It's no wonder that the local council uses it to show off the best of Exeter and to impress visitors. The local leaders understand that the investment they have made in this cultural asset pays dividends in terms of their city's reputation.

There's an exciting sense of artistic experimentation in Exeter too, epitomised by the Bike Shed Theatre, which you will find in a basement at the end of an alley in the heart of the city. As well as being a theatre, the Bike Shed is also a cocktail bar. If you visit, do try the 'Penicillin' – a blend of Great King Street Glasgow whisky, King's Ginger liqueur, honey and lemon. I'm not sure how efficacious it is at warding off coughs and colds, but if you knock back a few of them, you certainly forget that you've got any symptoms. I was there on 21 October 2015, better known as 'Back to the Future day'. This was the day travelled to by Michael J. Fox's character Marty McFly in the 1989 film *Back to the Future 2*, to find a world of flying cars, shoes with self-tying laces and skateboards that hover above the ground. With the film playing on a screen in the background and over a soundtrack of the 1980s hits of my childhood, Bike Shed's dynamic young director David Lockwood explained to me how revenues from the cocktail bar enable him to develop and programme innovative new writing and productions.

" *It can take years of insight, consistency, productivity, creativity, vision, knowledge, practice and timing to build up a positive reputation.* **"**

His mixture of art and enterprise is proving to be every bit as potent as the drinks on offer in the bar.

Further along the Devon coast, in Plymouth, the City Council has placed investment in culture at the heart of its plans for expansion. A major capital investment in a new History Centre is designed to transform the city's museum, rehouse its archives and provide a new contemporary visual arts gallery of national and international significance. Plymouth City Council sees art and culture as central to building the reputation of its city. Alongside the investment in the History Centre, the city played host to a series of major new festivals in 2015, with the Plymouth Arts Weekender involving more than 300 artists and community groups in 85 events and the city's first Fringe Festival providing a week-long festival of theatre. Then there was the National Youth Dance Festival featuring more than 1,000 young dancers.

The decision to host the British Art Show in Plymouth in 2010 was a major landmark on the city's journey towards being a recognised artistic hub. It was a catalyst for a new generation of artists to make the city their home. I met a few of them hard at work at Ocean Studios, a wonderful gallery and artists' workspace newly built as part of a redevelopment of Royal William Yard Harbour, a set of Grade 1 former Royal Naval victualling buildings.

Ocean Studios is at the centre of the redevelopment. This is something of a trademark venture for Urban Splash, the property developer behind the scheme. It has specialised in recreating new living and working spaces from old industrial buildings in cities

around the country. For Urban Splash's chairman Tom Bloxham, it's not only about getting the mix of cafés, bars, restaurants, offices and residential spaces right. For him, having culture at the heart of a development is what makes it special. He has taken the oath sworn by the citizens of Athens as his company's motto:

'We will leave this city not less than greater, better and more beautiful than it was left to us.'

In 2015, Battersea Arts Centre in south-west London suffered a devastating fire that resulted in an instantaneous and heartfelt outpouring of support from all parts of its local community. From the depth of their response, it was clear that for people living in Battersea, this was far more than just a building that put on performances. Over many years, it had built up a reputation for the high quality of its artistic work, and for its extensive engagement with people in the area. At the beginning of 2016, I sat on the judging panel for The Agency, a programme run by Battersea Arts Centre and Manchester's Contact theatre that helps young people develop their own entrepreneurial ideas through creative workshops. As judges, we were asked to pick three of these projects, which would be given £2,000 of funding alongside mentoring and support to help make their ideas a reality. It was well worth spending time on a Saturday for; I came away inspired by the creativity of the young entrepreneurs. This was a project that used creative practice in a truly innovative way and brought young people to Battersea Arts Centre who might not otherwise have come. David Jubb, the organisation's artistic director, makes a point of including people who live in Battersea in everything that goes on inside the building.

On my way home, I reflected that it was therefore unsurprising that the venue was held in such high regard by its local community. It had earned its reputation.

In the north-east of England, the power of investment in culture as a means of building reputation has long been recognised. Back in 2002, Gateshead Council leader Mick Henry told the *Guardian* about his vision for using culture to change Gateshead's reputation:

> *'We want to change the image and perception of Gateshead, creating a new city centre along the Quays, while bringing art to the masses and getting over the message that you don't have to go to London to enjoy art and good music. People are becoming proud of Gateshead and they see a future here once again.'* [2]

Turn the clock forward a decade and a half and Mick Henry's vision has become a reality. The Baltic contemporary art gallery and the Sage Gateshead concert hall are now cultural fixtures with a national and international reputation, alongside Gateshead Council's investment in public art, which includes *The Angel of the North*, Antony Gormley's magnificent sculpture that towers above Tyneside's main transport links.

Political, cultural and business leaders in the North East have recognised the power of arts and culture to build the region's

[2] Hetherington, Peter, 'Baltic redefines cold Gateshead as hot spot', *Guardian* (12 July 2002)

reputation. In 2015 this was codified in a new document 'The Case for Culture', published by the North East Cultural Partnership, a group which brings together all twelve local authorities and five universities in the area, with funding from Arts Council England. Cultural entrepreneur John Mowbray, the co-chair of the Partnership, says it sets out an ambitious plan for growth based on investment in arts and culture in the area:

> 'The Case for Culture builds on a long tradition in the North East of positively promoting and championing culture and creativity. It will be an important tool in influencing key decision-makers across a range of sectors. We believe it will play a valuable role in establishing the credibility, expertise and significance of the cultural sector to the economic life, health and well-being of the whole of the North East.'[3]

When arts and culture organisations work closely together, they often achieve better results than if they go it alone. The Liverpool Arts Regeneration Consortium was born in the run-up to the city's time as European Capital of Culture in 2008. It sees seven of Merseyside's major cultural organisations joining together in an alliance that uses culture as a tool for regeneration in the city. Meanwhile, in Coventry and Warwickshire, eight of the area's biggest cultural attractions have come together as CW8, working to build the reputation of arts and culture there. When I met some of its key players at the Compton Verney art gallery in the beautiful Warwickshire countryside, they were keen to point out that though

[3] http://www.northeastcouncils.gov.uk/news/press-releases-2015/ northeasttakescaseforculturetowestminster

a relatively young organisation, they were already achieving more success by working together than they would do if each cultural organisation were operating separately.

Whether it's the Barbican Centre in the heart of the City of London with its concert hall that's home to the London Symphony Orchestra, as well as its theatre, art gallery, cinemas and library; the Southbank Centre with the Royal Festival Hall, Queen Elizabeth Hall and Hayward Gallery next to the River Thames; the Royal Shakespeare Company in Stratford-upon-Avon; The Curve theatre in Leicester; Tate St Ives in Cornwall; or the Royal Opera House's production workshops in Thurrock; investment in art and culture has been at the heart of changing, developing, enhancing and driving forward the reputation of places. Without the inner light of success from arts and culture, the reputations of some of these places might be much diminished.

It's not only at home that reputations are built; the UK is acknowledged around the world for the influence and quality of its creative sector. For an island our size, we punch well above our weight; UK music exports, for example, generated £2.1 billion of revenue during 2014[4] and London's art market is estimated at more than £9 billion.[5] Fast-growing countries such as South Korea and China are studying our specialist conservatoires and arts universities to understand how the creativity included in our education system has enabled us to become so proficient at producing a

4 http://www.thecreativeindustries.co.uk/media/320723/measuring_music_2015.pdf

5 'Cultural Times: The First Global Map of Cultural and Creative Industries', Ernst & Young (2015)

generation of world-leading writers, artists, actors, designers, directors, photographers, producers, curators, composers, musicians and software developers.

Audiences all over the world enjoy our creative output. Much of this is developed in this country through Arts Council investment and then toured around the world thanks to partnerships with the British Council and with UK Trade & Investment. These international tours can make a significant difference to an arts organisation's bottom line, helping to sustain their work in this country.

The Royal Shakespeare Company, the Royal Ballet, the London Philharmonic Orchestra, the Akram Khan Dance Company, and the Victoria and Albert Museum's *David Bowie Is* exhibition are all examples of organisations that receive public investment for high-quality work in England – and build on that investment to take this work to audiences around the globe, helping to drive up our entire country's reputation as a creative leader.

It's sustained and strategic investment in art and culture that has made this possible. This investment has made our villages, towns and cities better, more creative places to be. It's enriched our lives, increased our knowledge and opened our minds to new possibilities, helping us to be happier and healthier. It's given the UK huge equity on the international stage, building our reputation as an innovative and creative country.

This is the Arts Dividend. It's investment that pays. And we squander that investment at our peril.

acknowledgements

I am very grateful to all of my colleagues in each of the nine offices across Arts Council England who have shared their insight, expertise, experience and passion for arts and culture with me over the past twelve months. They are a great bunch of people who do more than anyone else in this country to ensure that public investment in high-quality arts and culture pays dividends for people right across England.

In particular, I would like to thank those who have read sections of this book, making incredibly helpful comments along the way: Abid Hussain, Alison Clark, Althea Efunshile, Brian Ashley, Cate Canniffe, Clare Titley, Dawn Ashman, Ella White, Francis Runacres, Gill Johnson, Hedley Swain, Helen Sprott, Jane Tarr, John Orna-Ornstein, Joyce Wilson, Laura Dyer, Laura Gander-Howe, Liz Bushell, Mags Patten, Michelle Dickson, Neil Darlison, Nick McDowell, Paul Bristow, Peter Heslip, Peter Knott, Phil Cave, Phil Gibby, Richard Russell, Ross Burnett, Sarah Maxfield, Simon Mellor, Will Cohu and Sir Peter Bazalgette.

My thanks are also due to Arts Council England's excellent research team – Andrew Mowlah, Vivien Niblett, Jonathon Blackburn, Eloise Poole and Marie Harris – who together

commissioned or produced much of the published research upon which I have relied in the writing of this book.

Thank you also to Maria Hampton, Beth Kahn and Teresa Drew who have done so much to ensure that my first year at the Arts Council has run smoothly.

I am, as ever, indebted to Lorne Forsyth, Olivia Bays, Jennie Condell, Pippa Crane, Alison Menzies, Marianne Thorndahl and Jonathan Asbury at Elliott & Thompson for their careful stewardship of this book from concept to print with their customary patience, attention to detail and immense good humour.

Finally, a big thank you to all of the artists and leaders of arts organisations, museums, libraries, education institutions and local authorities whom I have met over the past twelve months. All have been very generous in sharing their time and ideas with me. I have seen, heard and learned so much more than I could possibly fit into this book and I apologise now to the many wonderful people, places and organisations that I haven't been able to include in these pages. You're already playing your part in making the Arts Dividend a reality in so many people's lives. Together, we can all ensure that great art and culture enriches the lives of so many more.

index